UNSEEN
CHESTER

T0323080

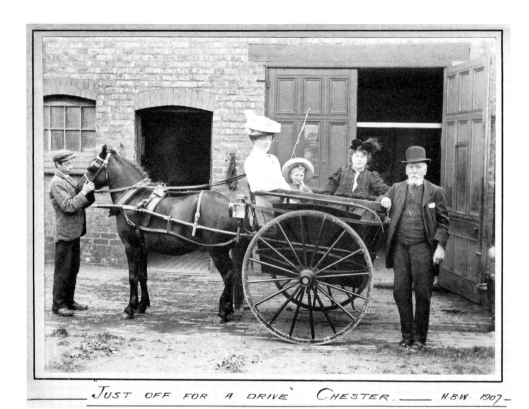

"JUST OFF FOR A DRIVE" CHESTER. ____ H.B.W. 1907

A family with pony and trap set off for a drive around Chester in 1907 to view the many attractions of this beautiful city. This book will also take the reader on a tour of many of the places the family would have visited.

UNSEEN
CHESTER

DEREK STANLEY

First published 2017

The History Press
The Mill, Brimscombe Port
Stroud, Gloucestershire, GL5 2QG
www.thehistorypress.co.uk

British Library Cataloguing in Publication Data.
A catalogue record for this book is available from the British Library.

ISBN 978 0 7509 8117 0

Typesetting and origination by The History Press
Printed and bound in Great Britain by TJ International Ltd

CONTENTS

ACKNOWLEDGEMENTS

I am grateful to those friends who have helped me in the research and preparation of this book. In particular I should like to thank Keith Hough, Geoff Ellis, Keith Hobbs, Reg Eaton, Gillian Jackson, staff of Cheshire Military Museum, the Chester Heritage Centre, Chester Reference Library, and the City and County Record Office. I would also like to thank the staff at The History Press, particularly Nicola Guy, Emily Locke and Matilda Richards. I would especially like to thank my wife Theresa, who has always given me so much support and encouragement.

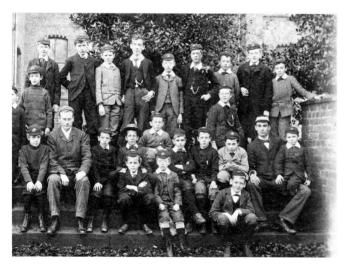

Boys from Arnold House School (1884–1910) photographed c.1895. The school was on the corner of Parkgate Road and Walpole Street. This was a private preparatory school for young gentlemen and a few of the older boys are sporting pocket watches with fob chains. Some of these young men will have fought for their country in the First World War. There is an Arnold House Memorial Window in Chester Cathedral dedicated to the memory of the pupils who lost their lives in the war. The list includes names from many well-known Chester families. When the school closed in 1910, the Kings School acquired the premises. It then became the Kings Junior School and School Boarding House.

ABOUT THE AUTHOR

Derek Stanley is a retired GP and former Chester city councillor who has lived in the city for over forty years. He is a keen local historian and is the author of three books on Dublin and one on County Wicklow. This is his first book on Chester and he hopes it will be read and enjoyed for many years to come.

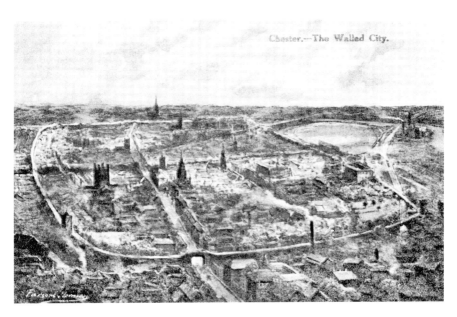

A postcard illustrating the 'Walled City of Chester' by the artist George Parsons-Norman (1840–1914), which was published by Phillipson & Golder. It shows the Roman walls enclosing the older parts of the city with the four streets from the main gates meeting at the Cross. The view is from the Northgate and the three landmarks are, from left to right, the cathedral, the Town Hall, and the castle.

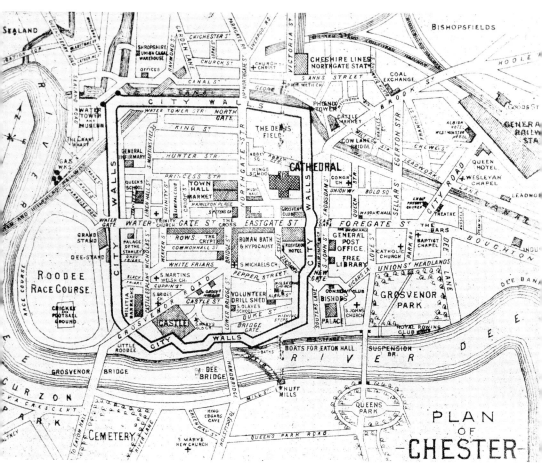

Plan of Chester taken from an early magic lantern slide showing the walled city and the surrounding areas. The Roodee is on the left between the River Dee and the Watergate. During Roman times it was part of the River Dee Estuary and boats coming to the Port of Chester could anchor at the harbour walls near the Watergate. However, as the Dee progressively silted up boats could no longer reach Chester. The land became a meadow and was reclaimed, to be used for pasture. It has been a racecourse since the early sixteenth century. The Shropshire Union Canal skirts the city walls to the north. Chester General Railway Station is shown on the right at the end of City Road.

INTRODUCTION

Chester is a beautiful place and this book seeks to capture its spirit and charm through old postcards and photographs which evoke memories of the historical and cultural riches of the city. The pictures are from my own collection and include many which come originally from old lantern slides, reproduced here for the first time. Chester has been much photographed in the past and some images in this book will have appeared in other publications; however, they are included here to help create continuity and completeness in each chapter. I hope that readers will understand the reasons for their inclusion.

Chester has had a vibrant history and although it is an ancient place it continues to have a youthful spirit which embraces the past and looks towards the future. Many of the images of old Chester show a very different appearance to the city we know today, and it is hoped that readers will enjoy comparing the streets and buildings of yesteryear with those of the present.

It is fortunate that the work of local photographers and postcard manufacturers in the early 1900s is still available. These images help us recall nostalgic memories of people, events and places in Chester which are part of our heritage. Of necessity, in a book of this size, not all areas and events can be covered in great detail, instead the aim is to give a 'flavour' of this unique city and its historic past. The text for each photograph is not exhaustive and should be used only as a guide. Hopefully, perusing these pages will inspire the reader to carry out their own research into the history of these particular photographs.

Derek Stanley, 2017

1

THE CITY WALLS AND CANALS

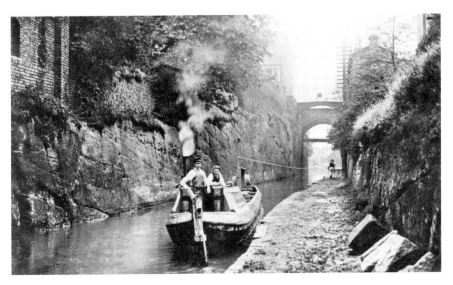

A view of the canal with the city wall on the left. The Romans originally dug out this deep wall to protect the northern part of the city. When the canal was built it sat naturally in this deep cutting. Above the canal, the first bridge is the 'Bridge of Sighs' which was built in 1793 to carry condemned prisoners from the gaol at the Northgate to receive the last rites at St John's Chapel. This was next to the Bluecoat School in Upper Northgate Street. A horse on the towpath is pulling the barge on its way to the Northgate Locks.

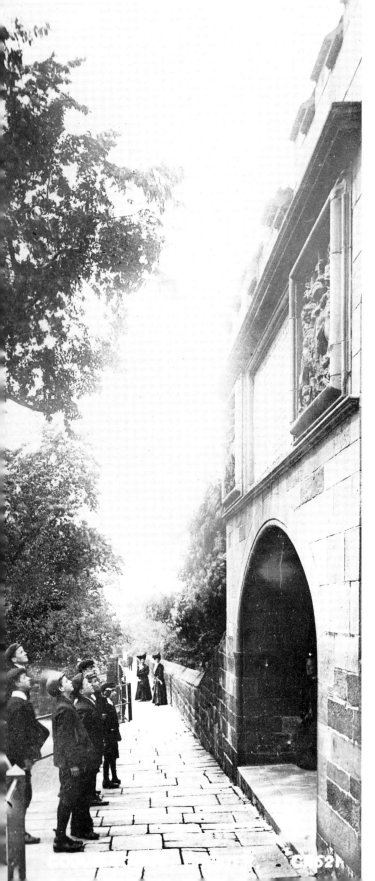

Left: Spectators at the Goblin Tower on a postcard dated 25 September 1906. They are looking at the two scrolls carved by John Tilston and the plaque which records the names of past Chester mayors and men responsible for the upkeep and repair of the wall between 1702 and 1708. There are almost 2 miles (3km) of unbroken rampart walls of Roman origin although there was some Saxon and medieval refortification. As late as 1571 Braun's map of Chester showed there were seventeen towers on the walls. The Roman military architects had directed that towers should be built on the walls within a bow-shot of each other. Only a few towers survive today. The Goblin Tower was previously a circular tower dating from the thirteenth century. It is now generally known as Pemberton's Parlour, as it was used as a vantage point by John Pemberton, the Mayor of Chester in 1730, to supervise the men working in his rope works below.

Right: The city walls at a point near the Northgate. The red sandstone wall, which in this section is 22ft high, was thick enough that two armed soldiers could walk past each other without a problem. The imposing walls surrounding Chester are between 20 and 30ft high and were usually an effective defence against attack. The weakest point was always the gates of the city, which would frequently be the first point of assault for an enemy.

The Walls
CHESTER

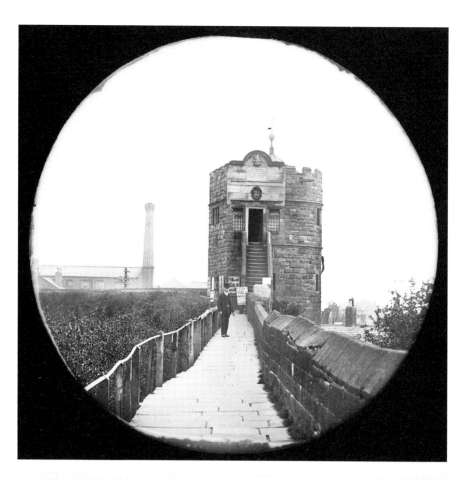

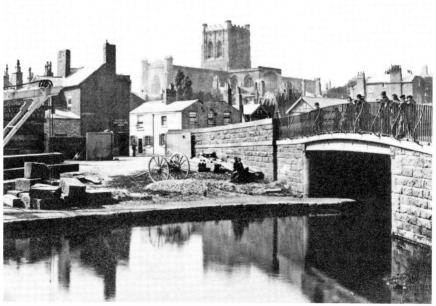

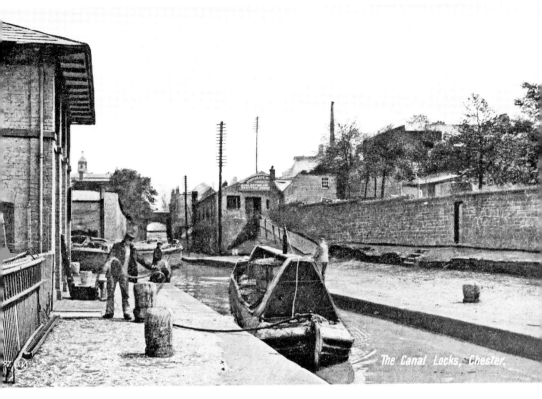

The Canal Locks, Chester

Above: A postcard showing the Northgate Locks on the Shropshire Union Canal at Chester, *c.*1905. The locks were built in 1795 as a staircase of three locks. The Bridge of Sighs (see page 11) is in the distance over the canal. On the left, a barge is tied up at the lock-keeper's cottage. Chester's Inner Ring Road now crosses over the canal near the cottage and the new St Martin's Gate, which was opened by Barbara Castle MP in 1966, is now by the wall on the right

Opposite top: A view of King Charles Tower taken from a lantern slide, *c.*1870. The Tower stands on the walls on the site of the original Roman north-east tower. From here, on 24 September 1645 during the English Civil War, King Charles1 watched his Royalist forces being defeated in the Battle of Rowton Moor. It is also known as the Phoenix Tower as it was once a meeting house for the Painters' Guild and their emblem in the form of a phoenix statue is shown over the doorway under the top arch. On the left is the tall chimney of the Providence Iron Foundry in Newton, which was owned by H. Lancely & Son.

Bottom: A photograph of Chester Cathedral taken from Cow Lane Bridge in Frodsham Street by Francis Bedford, *c.*1890. A group of men are on the bridge passing the time away looking into the waters of the canal. A sign on the side of the building on the left reads 'Hankey, Odd Fellows Arms'. The pub was built around 1770 and stands on the same corner in Frodsham Street today. There have been many changes to its surroundings in the past century including the closure of the Cattle Market at Gorse Stacks and the building of the Chester Inner Ring Road. It remains a popular local pub close to the canal.

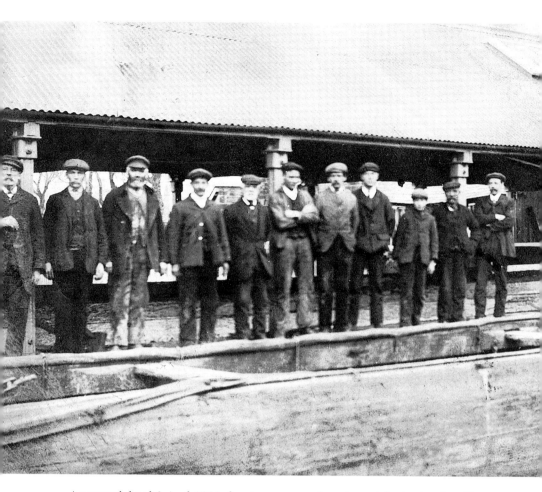

A postcard dated 3 April 1911 showing a group of workers at the boatyard at Chester Canal Basin, Raymond Street, Chester. On the north side of the Basin was Taylor's Boat Yard, which built and maintained traditional canal boats. At this time the Shropshire Union Railways and Canal Company owned the canal and operated a large number of boats.

2

THE CROSS AND PRINCIPAL STREETS OF CHESTER

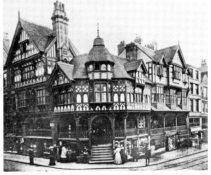

This postcard of Chester Cross was issued in the early 1900s and shows two images of the corner of Eastgate Street and Bridge Street from St Peter's Church. The left view dates from the 1860s and shows the corner shop owned by Mr Brewer. This sold ironware including buckets and watering cans, as seen hanging outside his shop. A crowd stands outside the butcher's shop, which has a fine selection of meat on open display. The right view dating from 1905 shows a much altered street corner. In 1888, the Duke of Westminster had the old buildings rebuilt using plans drawn up by the architect Mr T.M. Lockwood. The new black and white buildings with the familiar steps were a better match for the Rows and continue to be much admired by visitors to the city.

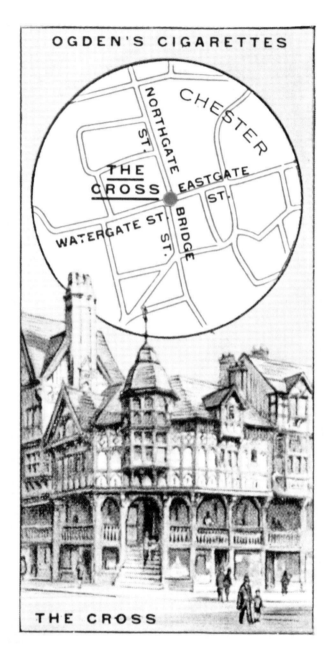

A card issued with Will's cigarettes showing how the four principal streets, containing the unique Rows, radiate at right angles from Chester Cross to terminate in the four old gates of the city. The Roman headquarters were near to St Peter's Church. Towards the end of the twelfth century Lucian, a monk from Chester Abbey, wrote that 'Chester has four gates, which look on the east to India, on the west to Ireland, on the north to Norway and on the south to Wales'.

3

EASTGATE AND FOREGATE STREET

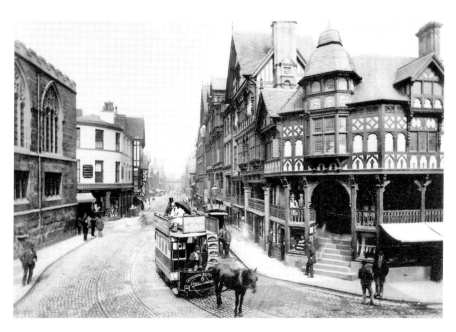

Chester Cross looking down Eastgate Street, c.1900. Horse tram No.6 is at the Cross turning into Bridge Street. This is the city axis and the picture shows a double track of tram lines so that trams travelling in the opposite direction could pass. On the left is the wall of St Peter's Church, at the junction with Northgate Street. The Chester Horse Tramway opened in June 1879; it linked Chester General Railway Station through the city centre to the castle and then to Saltney. Electric trams replaced the horse trams in 1903.

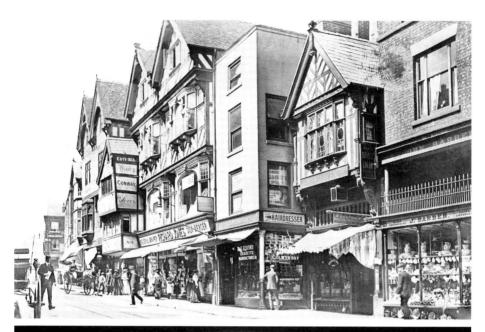

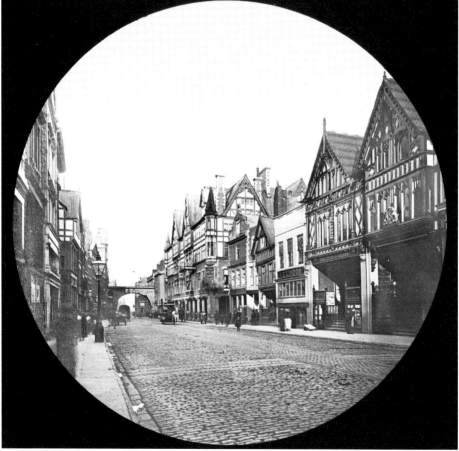

Opposite top: The north side of Eastgate Street looking towards the Cross and Watergate Street, 10 September 1903. On the right is John Barber's shop, selling glass and chinaware. Next, at street level, are booksellers Parry & Son. Above this shop, on Eastgate Row North, is the black and white gable of the Boot Inn. This well-known inn dates from 1643, when ships' timbers were used in its construction. It has had a chequered history. During the siege of Chester in 1646, Royalist troops who were drinking at the Boot Inn were attacked and killed by Cromwell's troops. In the 1890s there was a barber shop at the front of the pub, with a brothel at the back. Later, in the 1920s, one of the rooms was used for gambling. Today, this historic inn is a favourite hostelry for locals and visitors.

Bottom: The south side of Eastgate Street taken from a lantern slide, *c.*1890. Chester's famous Eastgate Clock has yet to be built. On the right at No.44 is the drapers shop owned by William Edward Lindop. This is next to the booksellers Phillipson & Golder, who also sold postcards. A horse car is passing the prominent frontage of the well-known Grosvenor Hotel on the right.

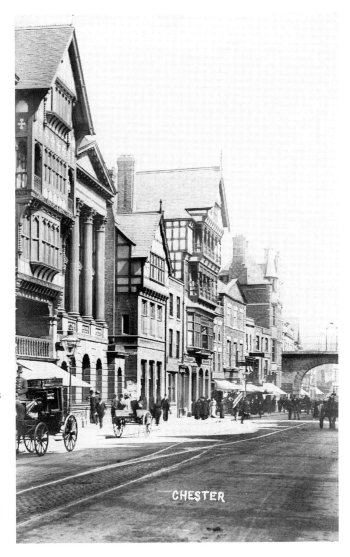

Right: The north side of Eastgate Street, *c.*1895. A stagecoach is on the left and a carriage stands outside Parr's Bank. This building was built by George Williams in 1860, featuring a neoclassical frontage with four columns. The bank is on the corner of St Werburgh's Lane, which was doubled in width between 1895 and 1899 to make what is now St Werburgh's Street.

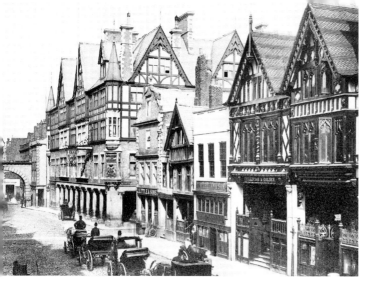

Eastgate Street, c.1880. Horse-drawn carriages queue in the centre of the street. They are waiting to pick up passengers from the Grosvenor Hotel, which was owned by the Duke of Westminster. The hotel was designed by the Chester architect Thomas Penson in the half-timbered black and white revival style between 1863 and 1866. Newgate Street is next to the hotel. This is now the entrance to the Grosvenor Shopping Centre.

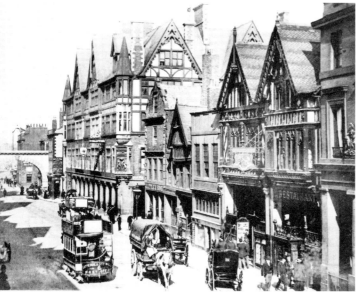

A busy scene in Eastgate Street, c.1885. Horse tram No.6, in the foreground, is heading for Chester General Railway Station. The family grocers, J. Little & Sons, are on the corner of Newgate Street. On the right, a coach waits outside Bollands Restaurant. The protruding Blossoms Hotel can be seen through the Eastgate arch; its frontage was changed in 1911 to align with the rest of the street.

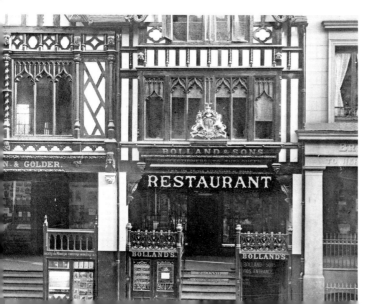

The impressive frontage of Bollands Confectioners and Restaurant, which was next to the bookshop of Phillipson & Golder in Eastgate Street, c.1890. There are steps up to the enclosed Rows. The royal coat of arms is prominently displayed on the shopfront. Bollands made wedding cakes for Queen Victoria. They were well-known confectioners and advertised fine cakes for customers, at home and abroad, which were the same as those supplied to the Royal Family.

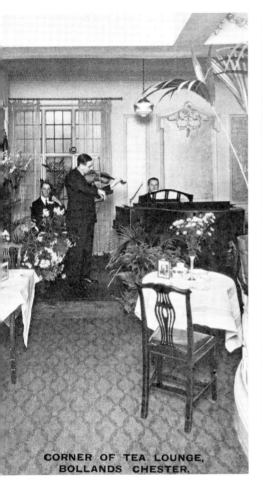

CORNER OF TEA LOUNGE,
BOLLANDS CHESTER.

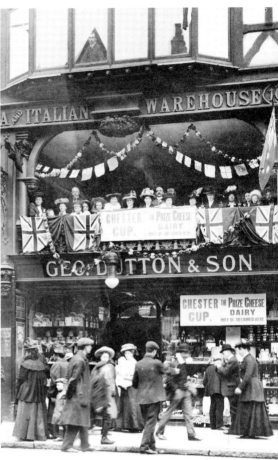

Above left: Around 1915, Bollands moved two doors down from No.40 Eastgate Row to make way for the exclusive Brown's Department Store, which was known as the 'Harrods of the North'. Bollands continued to do well in their new premises. The postcard shows musicians playing in the corner of the Tea Lounge in about 1930. The Bollands Trio comprised Mr Alby Hull on violin, who had played with the Liverpool Philharmonic and Halle orchestras, Mr F.W. Marchant on cello, and Mr A.B. Coleman on piano. They played daily for the diners in the restaurant, who sat at tables surrounded by potted palms. The trio proved to be a popular attraction for many years. However, by 1963, after business declined, Bollands Restaurant was forced to close and the premises were sold.

Right: George Dutton & Sons Sig-Ar-Ro stores and Tudor Café on Eastgate Street. The firm moved here in 1856 and during excavations on the premises in 1861 a Roman altar was discovered there. This altar is now in the Grosvenor Museum. The firm adopted the altar as their trademark using the phrase Sig-Ar-Ro which, when expanded, becomes 'Signo Arae Romanae' or 'Sign of the Roman Altar'. The shop had nine departments selling a variety of fine groceries, teas, coffees, cheeses, cakes, wines and spirits. The popular Tudor Café was on the first floor above the store. This postcard from 1900 shows the shop decorated with flags and bunting. There are signs advertising the Chester Cup. The families on the Rows are dressed for Chester Races at the Roodee.

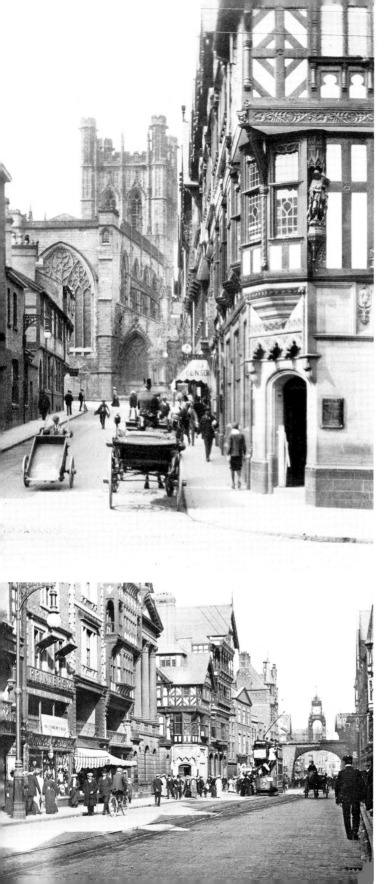

A fine view looking up St Werburgh Street toward Chester Cathedral, *c*.1900. On the right is the Bank of Liverpool and the row of half-timbered black and white buildings designed by John Douglas and built around 1895, when the road was widened. There is a carriage with a coachman in a top hat waiting outside the bank. The canopy over the pavement on the right advertises Densons, which sold hats and hosiery.

A busy Eastgate Street showing the Eastgate Clock, *c*.1900. This much-loved Chester landmark was added to the top of the gateway to celebrate the Diamond Jubilee of Queen Victoria three years earlier. It was designed by John Douglas and built by his cousin, James Swindley, a blacksmith from Handbridge. The clock and movement were made by J.B. Joyce of Whitchurch. The clock was ceremonially started by the Mayoress of Chester on Queen Victoria's 80th birthday, 27 May 1899. The tram in the centre has halted at the stop by St Werburgh Street to pick up passengers for Boughton.

A view from a lantern slide showing great activity in Eastgate Street, *c.*1902. The single tram line under the Eastgate splits to form two passing loops at this point. The cyclists have a bumpy ride and need to take care to avoid the tram lines. On the left is a garage sign belonging to the Grosvenor Motor Company.

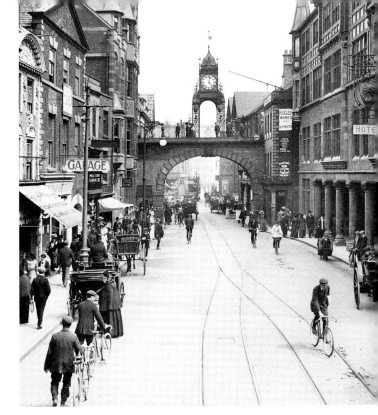

Eastgate Street, *c.*1920. The pavement is crowded with shoppers all wearing hats. The white-coated chauffeur waits by the splendid car. The curved sign for the Picturedrome Cinema can be seen on the left. This building was previously the Corn Exchange. In November 1909, Will Hunter opened a cinema upstairs which he originally called the Corn Exchange Cinema, but later renamed the Picturedrome in 1910. It showed silent films accompanied by music on every night except Sundays. It was a popular venue where people could relax and enjoy recent news events, comedy or action films. When the lease on the building expired in March 1924, the Picturedrome Cinema closed its doors for the last time.

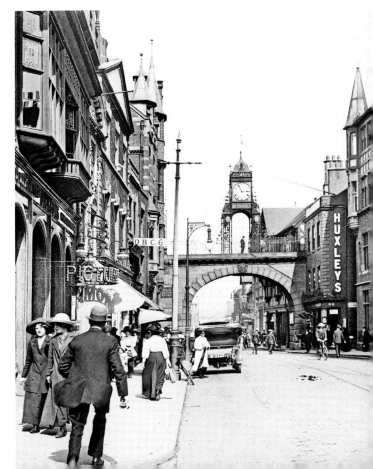

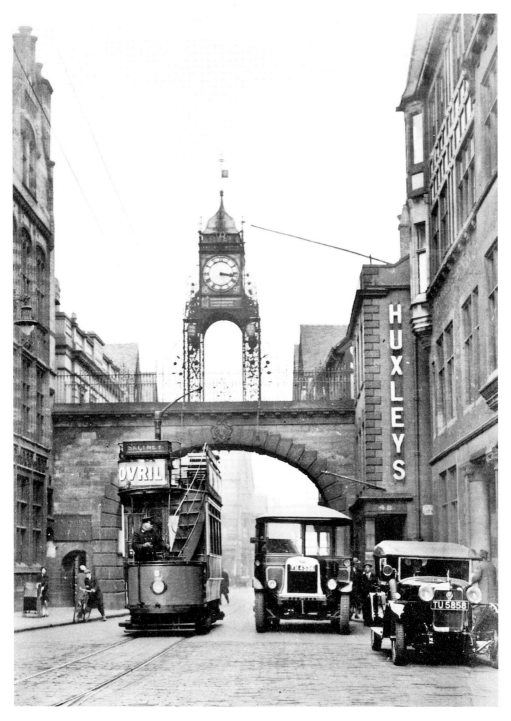

The Eastgate in the 1920s, showing a fine selection of transport: in the centre is the Chester Corporation tram No.8, which is passing a Crosville Leyland Lion single-decker bus. On the right, in front of the sign for Huxley's Wine and Spirit Merchants, is a splendid vintage Sunbeam car parked outside the Grosvenor Hotel.

A photograph of the Eastgate taken from Foregate Street, *c*.1880. It is probably early morning as Eastgate Street is deserted. On the right, at the junction with Frodsham Street, is the Hop Pole Hotel, which has a distinctive lamp hanging outside. Due to its location, this was a rival for Blossoms Hotel.

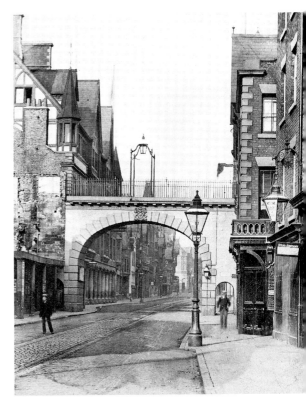

A view of the south side of Foregate Street on a postcard dated 10 May 1905. There is plenty of activity. Loaded carriages are passing under the Eastgate. On the left, a man is standing at the entrance to the City Dining Rooms, which have a decorative advertising lamp hanging outside. Next door to the Dining Rooms are G.S. Pye's premises, which carry a prominent curved banner advertising 'Finest Chester Pale Ales'. They also sold wine and spirits. The next sign hangs over the entrance to Francis Cottier's City Grill and Restaurant. On the right, a determined lady cyclist in her long skirts has a bumpy ride on the street cobbles.

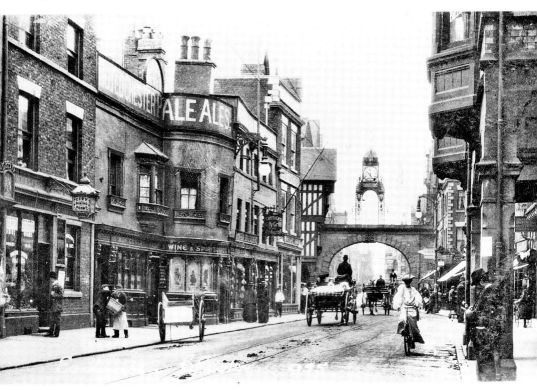

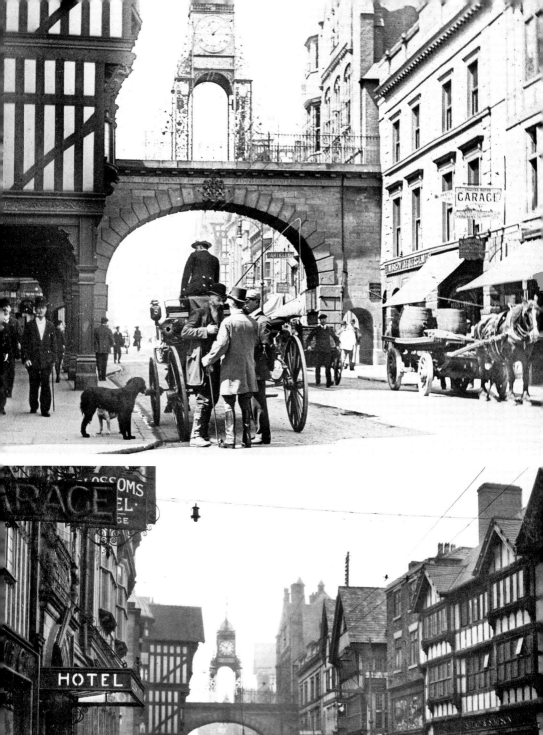
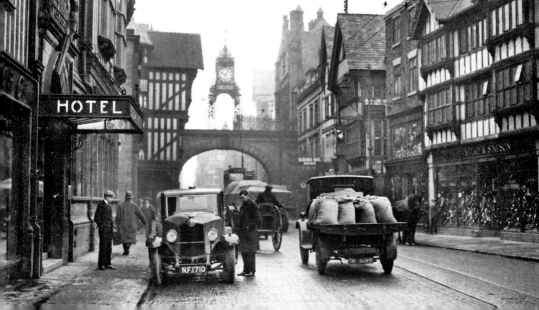

Opposite top: An interesting scene at the Eastgate taken from a glass lantern slide, *c.*1900. The photographer must have been standing on the corner of St John Street by the Blossoms Hotel. Three gentlemen are deep in conversation behind the carriage. The coachman and the dogs have to wait! On the right, a Great Western Railway dray has collected barrels from the order office for Chester Northgate Brewery.

Bottom: A busy Foregate Street in the late 1920s. On the immediate left is the garage sign for the Dee Motor Company which sold Rover cars. There is a fine vintage car parked outside the Blossoms Hotel, which is being admired by passers-by. The hotel, which dates originally from 1650, had extensive rebuilding in 1911, which added a new entrance and aligned the frontage with the rest of Foregate Street. The building on the corner of St John Street is the National Provincial Bank.

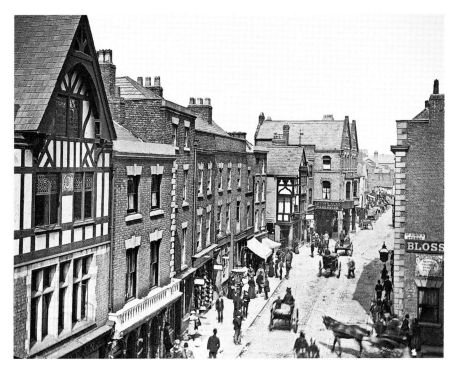

Above: Foregate Street viewed from the Eastgate, *c.*1890. It is a busy scene with many pedestrians and horse-drawn traffic. The sign for Blossoms Hotel is on the right. Since Roman times, when Foregate Street was known as Forest Street, the area was a commercial district with shops, fairs, market traders and businesses trading outside the city walls to serve the Romans with all their needs. When the Romans left Britain there was a difficult period when business suffered. However, during the Victorian and the Edwardian period Foregate Street saw much development with new building and reconstruction from the Eastgate as far as Boughton. At the time this photograph was taken the street was thriving with good hotels, pubs, shops and some Georgian houses.

The Old Nags Head on the north side of Foregate Street, taken from an old glass lantern slide, c.1880. The pub dates back to the 1780s when it had stables. The licensee in 1880 was Joseph Rydings. The pub was renovated in 1914 when the licensee was George Walker. It then advertised that it had a large garage with room for twenty-five cars. The pub finally closed in the 1970s. Only the frontage of the black and white timbered building remains today as in 1980 it was incorporated into the front of Boots the Chemist.

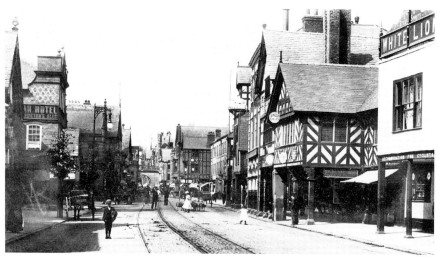

An interesting postcard dated 1906 showing a lady herding sheep down Foregate Street. Perhaps she has come from the Cattle Market. On the north side of the street at No.79 is the White Lion public house, which advertises accommodation for cyclists. The licensee in 1906 was Thomas Reynolds. The pub was owned by Edward Russel Seller & Co.'s. Brewery in Foregate Street; however, in 1891 they sold their business including the White Lion and some other Chester pubs to the Albion Brewery Co. in Wigan. This brewery ran the White Lion until 1919, when the business was sold to Threlfalls. The pub continued to trade until 1931. However, the building shown no longer exists as it was destroyed by a stray bomb during the Second World War.

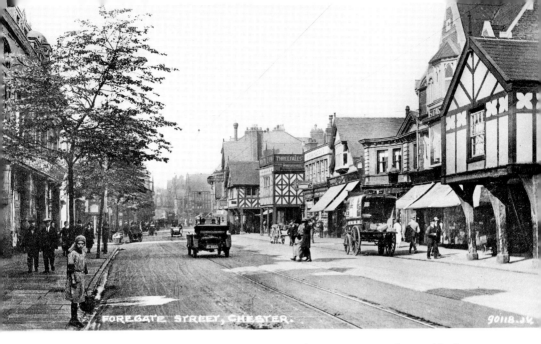

Foregate Street looking towards Boughton in the 1920s. The pavements are busy with shoppers. Motor cars have now made an appearance but it is still easy to cross the road. On the south side of the street, a sign for Threlfalls is displayed on the side of the White Lion Hotel, which now has a new black and white design on the outside of the building.

A peaceful scene showing the south side of Foregate Street, *c.*1890. The lady in the shawl is outside the Golden Lion Hotel at No.24, which has a lamp hanging outside. The hotel advertised good accommodation and also had stabling for horses at the rear. From 1876 to 1917 the licensees were the Watkins family. Next door, at No. 22, the Williams brothers' butchers has a fine display of meat carcasses hanging over open counters. This is where Marks & Spencer opened their new department store in 1932.

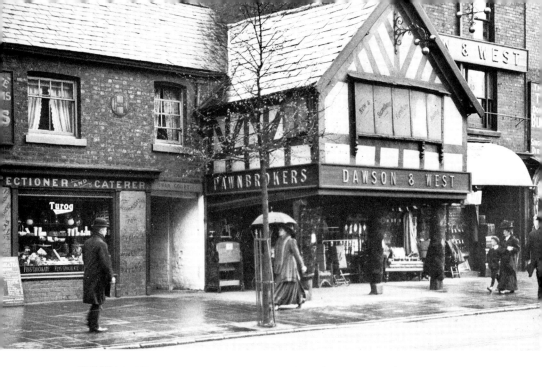

A rainy day in Foregate Street, c.1900. At No.58 is Anthony Durish, a baker and confectioner. Next door at Nos 54-56 are the pawnbrokers, Dawson & West. On the right of the photograph at No.52 is the drapers shop owned by Mr Edward Dyson.

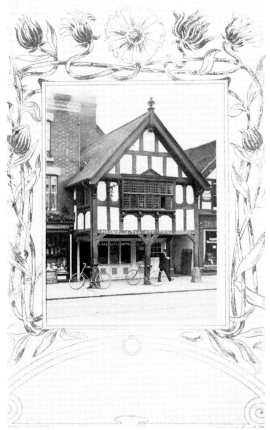

A postcard view of the black and white timber-framed building which was Haswell's Café at Nos 68-72 Foregate Street, in the 1920s. The Haswell sisters were the daughters of Charles Haswell, a muffin maker who traded in Frodsham Street in the 1850s. The daughters moved into these premises in 1870 and opened refreshment rooms and a muffin shop. The business thrived and their high-quality muffins attracted many regular customers. In the early 1900s, a number of meetings supporting the women's suffrage movement were held in the first-floor tearooms. The sisters traded from 1870 to 1920, when they sold the café to Josiah Whate.

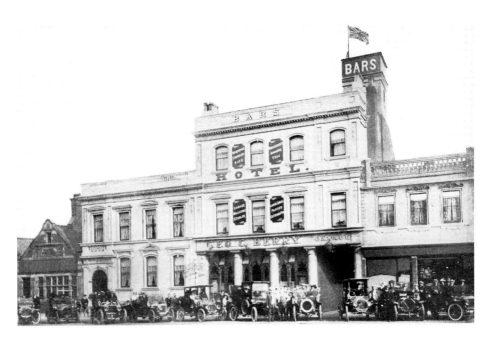

This advertising postcard dated 15 August 1914 shows a selection of ten vintage cars parked in front of the Bars Hotel at No.148 Foregate Street. The proprietor at that time was George C. Berry, who had previously been the licensee at the City Arms in Frodsham Street. The hotel advertised garaging for 100 cars.

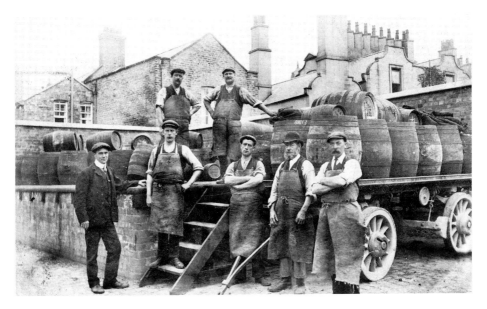

Men stop for a photo while unloading kegs of beer from a trailer at the rear of the Bars Hotel in the 1930s. The beer came from Greenall Whitley's Brewery, which supplied the hotel. It was hard physical work to lift the barrels from the trailer and the men had none of the mechanical aids used today.

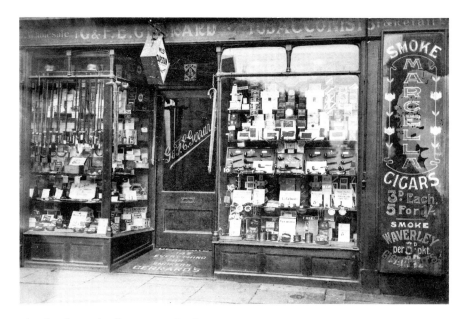

The shopfront of Gilbert Gerrard, tobacconist, at No.127 Foregate Street. There is a fine selection of pipes and cigars in the window. Marcella cigars are advertised at 3 pence each or five for a shilling. The welcoming mat at the shop entrance states that 'Gerrard's has everything for smokers'.

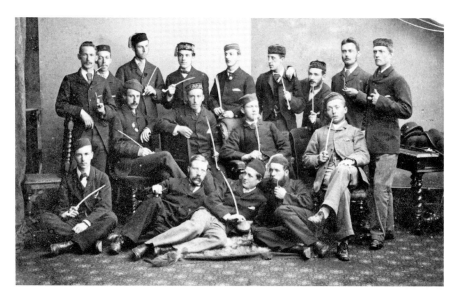

Smoking clubs were popular, as demonstrated by this photograph taken by George Watmough Webster at his studio at No.19 Bridge Street Row. It shows a group of young men with clay pipes, probably from Chester College, where smoking clubs were formed around 1895. Most of them wear Victorian smoking caps or lounging caps, some of which are embroidered and have tassels. They were designed to keep hair free from smoke as ladies often did not approve of smoking.

4

NORTHGATE STREET

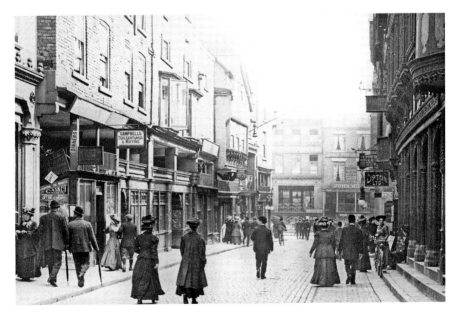

A busy Northgate Street with well-dressed shoppers heading towards Eastgate Street, c.1895. A hanging sign on the east side of the street invites customers to visit William Campbell's refreshment rooms for teas, light cakes and muffins. On the west side of the street are signs for the Commercial Hotel and Lipton's grocers shop on Northgate Row.

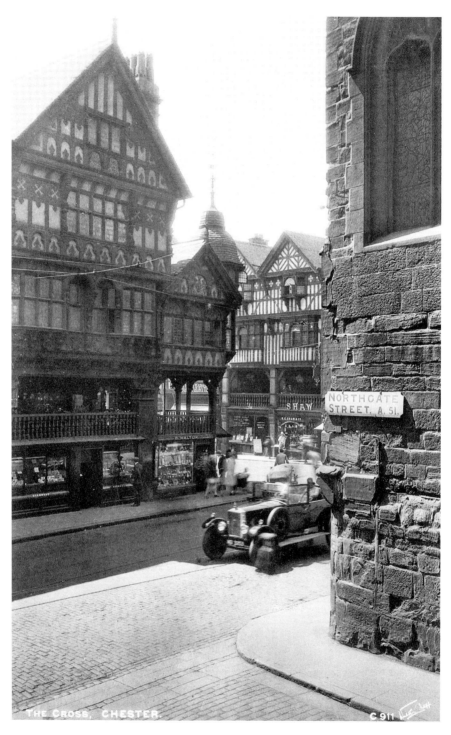

The Cross, Chester.

An unusual view of the Cross showing a splendid sports car with the hood down driving up Eastgate Street. The sign for Northgate Street, which is the A51, is displayed on the side of St Peter's Church. Shaw's ironmongers can be clearly seen in Bridge Street.

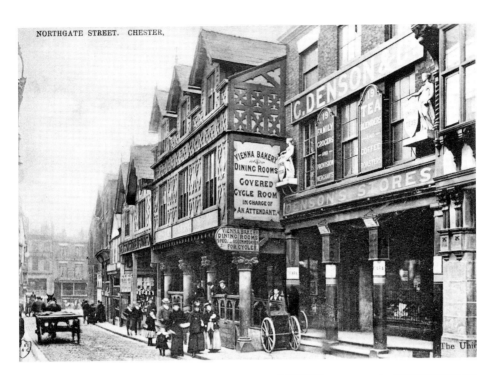

The old Shoemakers Row on a postcard dated 15 August 1905. Denson's was a family grocery and drapery store on Northgate Row. Before 1899 there were two tiers of shops on Northgate Row, at street and first floor levels. However, in the new Northgate terraced row the upper level is now enclosed.

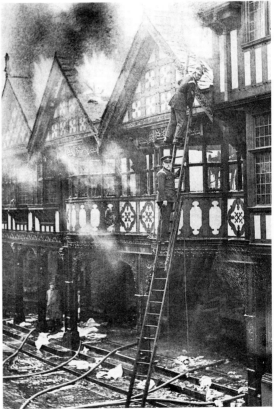

Firemen attending the fire at Denson's Stores on 5 June 1914. Hoses and debris lie on the ground and smoke billows from the building. However, at this stage the fire must have been under some control as the firemen on the ladder are surprisingly relaxed and looking at the camera. The *Chester Chronicle* on Saturday 6 June reported that Denson's shops were destroyed by the fierce blaze and that over 100 employees would have to take an enforced holiday.

Denson's stores had their own football team and this photo shows the Denson's United FC Store Team in 1913. The writer of the postcard – dated 11 April 1913 – says he is playing for Chester Denson's United FC against the team from the Nantwich store at the Northwich ground on the following Wednesday.

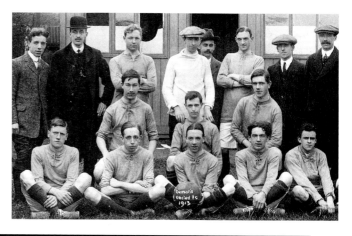

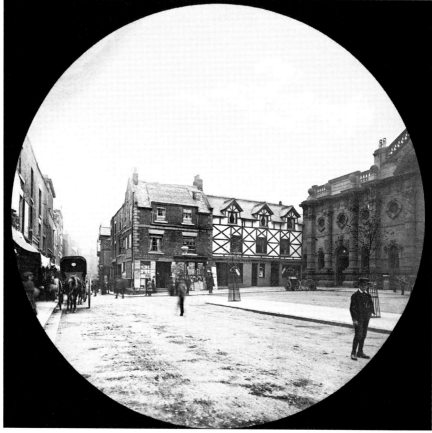

A view from an old lantern slide of Northgate Street looking towards Eastgate Street, c.1890. The Market Hall is on the right. The shop on the corner of Shoemaker's Row is W. Aston's wholesale newsagents and music stores. The black and white building next door became the Dublin Packet public house. The smartly dressed young boy on the right looking at the photographer is probably on his way to the King's School, next to the cathedral.

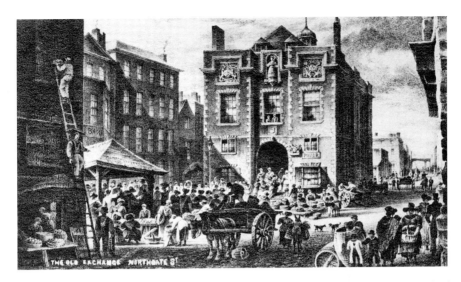

A sketch of the south front of the old Exchange Building or Town Hall in Northgate Street, which was built in 1695. The life-size statue of Queen Anne in her coronation robes, dating from 1702, is in the centre flanked by the royal coat of arms on the left and the Earl of Chester's arms on the right. The building housed the Mayor, city officers and the courts. The Northgate is in the distance on the right. Unfortunately the Exchange Building caught fire on 30 December 1862. The fire brigade attended quickly but did not have much power in their water hoses and were unable to control the blaze. It was reported that the gathered crowd mocked their efforts and the building burnt down.

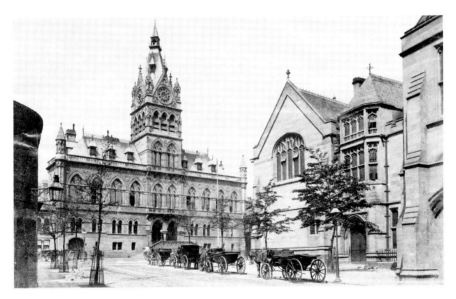

The imposing gothic-style Town Hall taken from the cathedral by Bedford, c.1895. The new Town Hall had been designed by Belfast architect William Henry Lynn. Inspiration is said to have been drawn from the medieval Cloth Hall at Ypres in Belgium, which has a similar central tower. At the time there was great debate about the costs to Cestrians and the need for a building on such a grand scale. Fortunately it was decided that the building should go ahead and the Town Hall was officially opened by the Prince of Wales (the future Edward VII) on 15 October 1869.

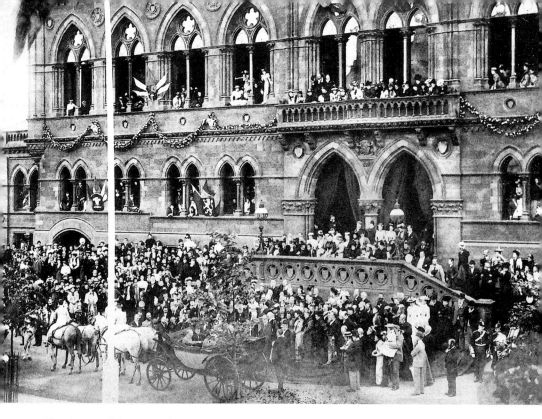

The Town Hall became a focal point of welcome for royal visitors to Chester. Here crowds in Town Hall Square line the steps and pack the balcony to witness the presentation of an address to Edward, Prince of Wales on 19 June 1893. There was a huge crowd of over 20,000 when the Prince attended the Royal Agricultural Show in Hoole on Tuesday 20 June.

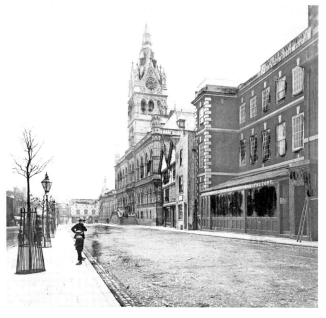

Looking down Northgate Street towards the Dublin Packet and Aston's Newsagent, c.1890. From right to left are the premises of William Hewitt, coach and carriage builder, the Elephant and Castle public house, the Coach and Horses Hotel, then Princess Street and the new Town Hall. In 1902 the coach and carriage business was bought by Mr J.A. Lawton. However, on Wednesday 1 July 1903 a fire spread rapidly and completely destroyed the building. Around 1913, the Westminster Coach and Motor-car Works was built in its place.

This photographic postcard shows the scene after the Council Chamber on the second floor of the Town Hall was gutted by fire on 27 March 1897. Joseph Davies with members of the Chester City Fire Brigade are looking with dismay at the destruction. Fortunately, the remainder of the Town Hall escaped major damage. However, the Council Chamber needed urgent work and it was restored by local architect Mr T.M. Lockwood the following year.

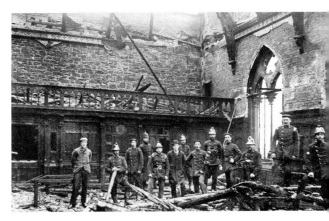

The old Market Hall with its grand frontage and the west side of the Town Hall are shown on this postcard, which was sent on 6 February 1909. It is hard to believe that any town planners would have allowed the baroque Market Entrance (built in 1863) to be demolished, but this happened in 1967, to be replaced by the Forum, whose days are now numbered. Northgate House in the far distance was formerly used as legal offices and the Judge's Lodgings. In 1936 this house was demolished and replaced by the Odeon Cinema, designed in the art deco style. Unfortunately the Odeon closed in 2006, leaving Chester city centre without a cinema. However, this building has now been rebuilt to become Chester's Storyhouse Theatre complex, which includes a cinema.

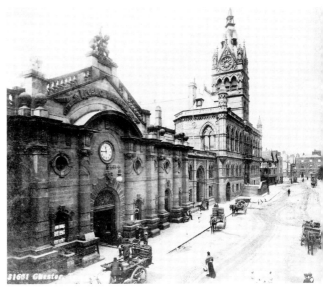

The Abbey Gateway, part of which dates back to the fourteenth century, is seen here on a postcard dated 21 July 1908. This was the main entrance to St Werburgh's Abbey Precinct. The annual Midsummer Fair was held outside the abbey gate in this wide part of Northgate Street when no other trading was allowed in the city. On the right of the gateway is the King's School which moved to this building, formerly the Bishop's Palace, in 1876. The King's School remained here until it moved to new premises on the Wrexham Road in 1960.

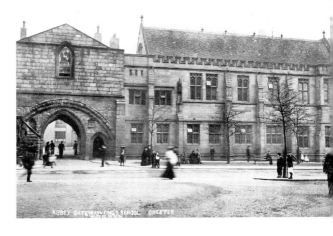

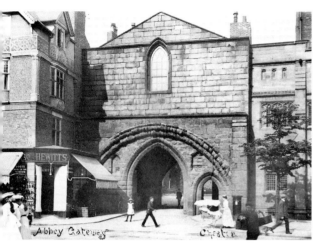

The Abbey Gateway, c.1905. There was once a prison cell above the arch and George Marsh, accused of heresy, was imprisoned here and tried at the consistory court in Chester Cathedral. He refused to recant his Protestant beliefs and was burnt at the stake at Boughton in 1555. There is now an obelisk erected in Boughton to his memory. The obelisk also bears the name of the Catholic martyr St John Plessington, who was hung at this spot on Gallows Hill in July 1679 for continuing to work as a priest in the Chester area.

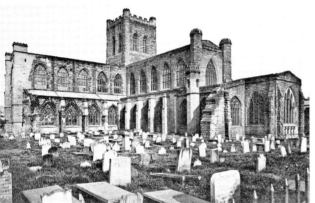

Chester Cathedral was founded in 1092 as a Benedictine abbey. It was built of soft red sandstone and by 1860 was showing evidence of general decay. There was urgent need for repairs and restoration, so Dean Howson engaged Sir Gilbert Scott as architect and the major rebuilding took place between 1868 and 1876.

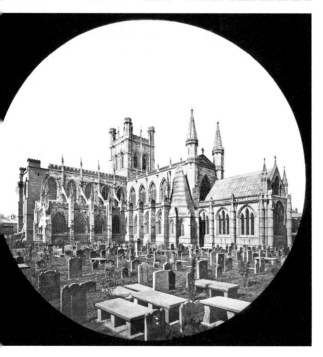

View of Chester Cathedral from the south-east about 1890, after Sir Giles Scott's major rebuilding and alterations, which included underpinning and replacement foundations for the eastern part of the cathedral. There were elaborate changes to the exterior appearance of the building, which can be seen in this photograph, including four small towers added to the top of the central tower. The changes were well received and generally most people felt the cathedral was much improved.

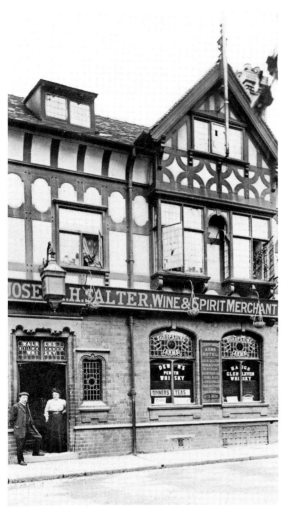

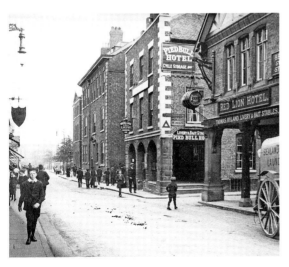

Left: The Shropshire Arms Hotel, No.47 Northgate Street. The proprietor, Joseph H. Salter, and his wife stand in the doorway. There has been an inn on this site since around 1750. It has had various names and was originally The Crown and Mitre and then around 1850 it was renamed The Liverpool and Shropshire Inn, as at that time many passengers travelling from Liverpool to Chester by barge on the Shropshire Union Canal would stay at the inn. It was renamed the Shropshire Arms in the early 1900s.

Below: The west side of Northgate Street, showing the Pied Bull Hotel on the corner of King Street. The hotel is Chester's oldest coaching inn. It was built with old ships' timbers and has some original Jacobean panelling. It was first licensed to serve alcohol in 1533 when it was called Bull's Mansion. The hotel was a coaching house with livery stables from 1784, serving the stagecoaches to Woodside at Birkenhead, where passengers could get the ferry to Liverpool. It also served coaches to Parkgate and Neston. The inn has played host to many visitors including the author George Borrow (1803–1881), who stayed there with his wife and daughter in July 1854. In his guide *Wild Wales*, Borrow was not very complimentary about the ale and cheese served at the inn as he describes spitting both out into the street. However, he did like the inn's buxom chambermaid! On the opposite corner of King Street is the Red Lion Hotel which has a conspicuous Bents beer barrel sign hanging from a model crane. The building dates from 1912, although the Red Lion had stood on this site since it was first licensed in 1781. Thomas Ryland was the proprietor when this photograph was taken. A wagon from the Sealand Road Laundry stands outside the Red Lion.

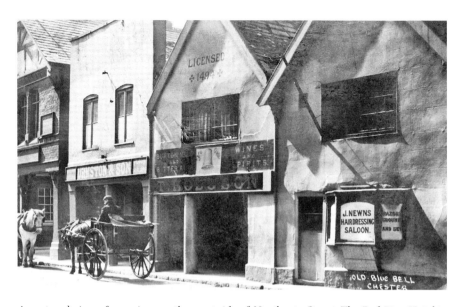

A postcard view of premises on the west side of Northgate Street. The Red Lion Hotel is on the far left. A horse and carriage waits outside Urmston & Son, a bakery. In the centre is the old Bluebell Inn and next door is J. Newn's hairdressing saloon, with a striped barber's pole stretching at an angle over the pavement. The saloon was built in 1684 and has a 'cabin window' which served as a stagecoach ticket office usually selling tickets for the packet boat crossing to Dublin. Less affluent passengers travelling on the roof of the coach could use a small window opening at the upper level where they could buy tickets.

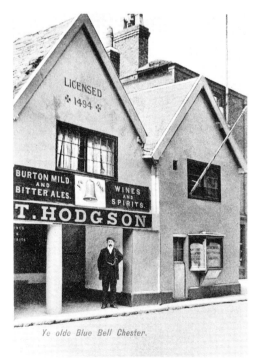

Ye olde Blue Bell Chester.

The Bluebell Inn was originally two houses built towards the end of the fifteenth century, although parts of the building are thought to be much earlier. It first became a licensed inn in 1494. Several generations of the Hodgson family ran the Bluebell Inn from 1826 to 1924. This photo shows the proprietor, Thomas W. Hodgson, standing outside the inn around 1914. At that time, his daughters Annie and Edith helped him to run the hostelry. The inn sold ales from Burton Brewery.

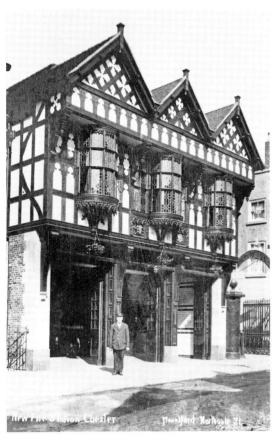

Mr Albert Clarke, the Superintendent Fire Officer, stands proudly outside the New Volunteer Fire Engine Station on the west side of Northgate Street. The building was designed by James Strong and opened in 1911. On the right of the fire station is the arched entrance with gates leading to the Northgate Brewery. The brewery dates back to 1760, when it was founded at the Golden Falcon Inn on Northgate Street. In the 1850s, new premises were built and the brewery expanded. It was bought by Greenall Whitley in 1949 and they ran the brewery for twenty years until its final closure in 1969.

The Northgate, *c.*1925. It is a quiet, overcast day. On the east side of the street at No.122 is R. Leach, a sub-post office and tobacconist, who has a fine display of postcards in his windows. Next door at No.124 is the tailors owned by Thomas John and then the entrance to Abbey Green, which now leads to Rufus Court.

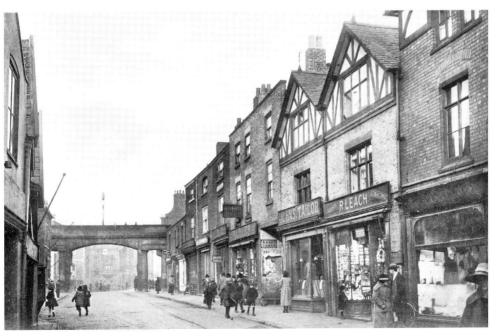

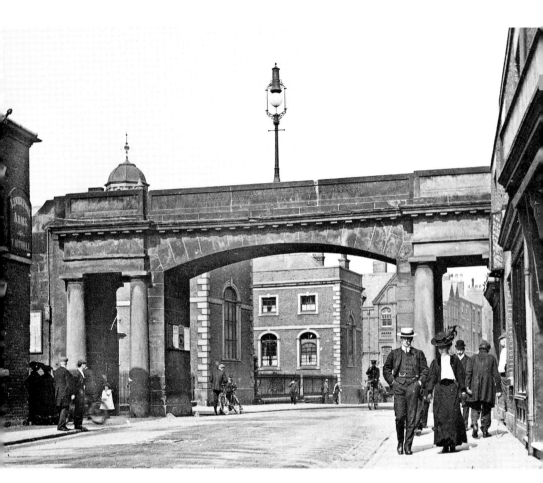

A view of the Northgate taken from an old lantern slide, *c*.1900. In Roman times it was the 'Porta Decumana' leading to the main street which ran from north to south in the city. There were a number of changes using the Roman foundations on this site and by medieval times the Northgate had large towers housing the city gaol. The cells for the prisoners, some of which had no windows, were built in the rock below each tower. Imprisonment in these dark, damp, stinking dungeons was a dreadful experience. In 1871, this infamous gaol was closed and prisoners then sent to the County Gaol at Chester Castle. The building seen through the arch on the west side of Upper Northgate Street is the Bluecoat School. This charity school founded by the Society for the Promotion of Christian Knowledge (SPCK) was built on the site of a medieval hospital and opened in 1717. Pupils were boarders and wore uniforms which included blue frock coats, breeches and caps. In 1790, a day school was opened which remained there until 1901. The boarding school finally closed in 1949. The building is now occupied by the University of Chester.

5

WATERGATE STREET

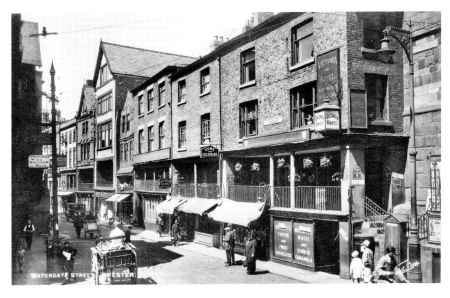

A busy Watergate Street viewed from the Cross in the 1920s. Horse-drawn traffic heads down the street. On the right, steps lead up to the Victoria Hotel. It has a lamp which provides some street lighting and also draws attention to the hotel at night. At street level is Noblett's Confectioner's shop. The shop blinds, which advertise Noblett's toffee, finest chocolate, rock and choice caramels, have been rolled down to keep out the sunlight. The next shops at street level are the Home and Colonial Stores and Arthur Wall's butchers shop.

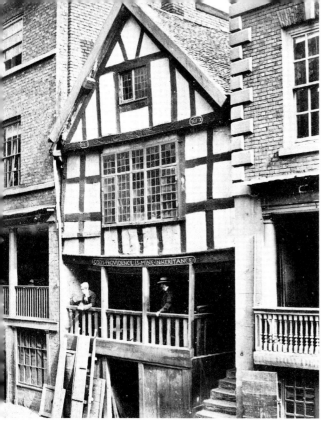

God's Providence House, c.1860. The plague came to Chester in 1666 and affected residents in every building in Watergate Street except for this house. Rats carried the fleas which caused bubonic plague but, at that time, people believed the plague was a punishment from God. The grateful owner thanked God and had inscribed on the front of the house 'God's Providence is Mine Inheritance'. In 1862 the building was reconstructed by James Harrison.

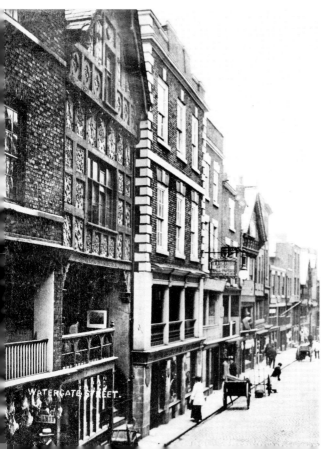

Looking down Watergate Street from the Cross on a postcard postmarked 15 March 1908. On the left, at street level, is Mr Joseph Barnett's shop at No.7, which sold fresh poultry from open counters. Next door is God's Providence House at No.9 which, after restoration, looks quite different to the original Tudor house in the previous picture. James Harrison preserved the front of the building using some original timbers, changing the windows and adding plaster detailing to the façade. However, the height of the building was increased and much of the house behind was rebuilt. It remains a very impressive building. At Nos 11–13 are the well-known wine and spirit merchants Quellyn Roberts. This building has a historic crypt dating back to medieval times.

An old photograph of Watergate Street, *c.*1895. On the left is Bishop Lloyd's Palace at Nos 51–53 Watergate Row (they were later restored by Mr T.M. Lockwood around 1900). This was originally two townhouses. It has two gables, one with elaborate carvings. The western gable (No.53) is dated 1615. The Palace was named after George Lloyd, who was Bishop of Chester from 1604 to1615. His daughter married Thomas Yale who had connections to the Erddig Estate near Wrexham. One of their sons, Elihu Yale, was born in Boston on 5 April 1649. He had a classical education followed by a successful career with the East India Company. He was a major benefactor to Conneticut College, which was renamed Yale University in his honour. He returned to England in 1699. He died in London on 8 July 1721 and is buried in the churchyard of St Giles in Wrexham.

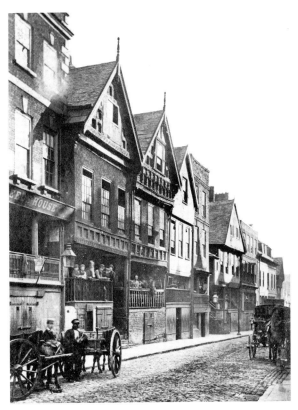

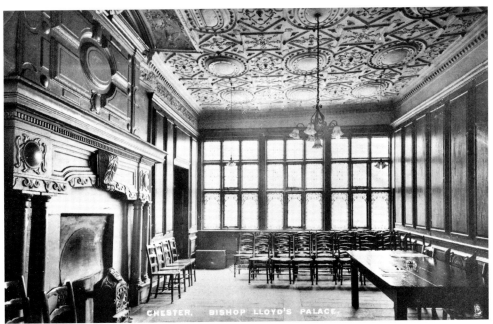

A postcard view of the interior of Bishop Lloyd's Palace. Note the fine ornate plaster ceilings, wood-panelling on the walls and the large marble fireplace.

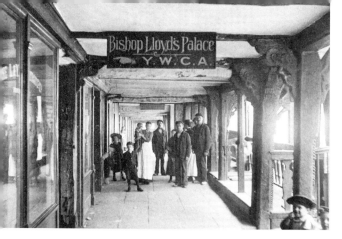

A group of parents and children wait on the south row of Watergate Street outside Bishop Lloyd's Palace, *c.*1910. The sign shows the way to the Palace. At that time the Young Women's Christian Association (YWCA) worked from Bishop Lloyd's Palace. They provided counselling and advice for young women and would give practical and financial help to those in need.

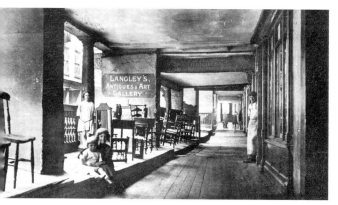

An atmospheric view of Chester's unique Rows (or covered galleries) in Watergate Street. In the past, similar rows linked all the properties in the four main streets. Today much of the Rows still exists and is a great asset much loved by Cestrians and visitors to the city. This postcard from around 1905 shows fine old furniture on display from Langley's Antiques & Art Gallery, while on the left a group of children pose for the photographer.

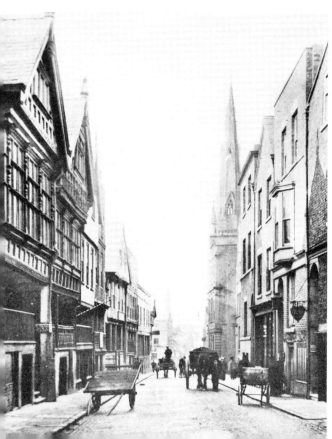

A quiet Watergate Street looking towards the river, on a postcard dated October 1903. Horses are hard at work pulling loaded carts up the hill. The Rows on the left were once known as Candlemakers Row due to the large number of candle makers working there. The spire of Holy Trinity Church, which was rebuilt in 1869, is on the right. It is the only church within the city walls which has a spire. It is now Chester Guildhall.

The Old Custom House Tavern at the corner of Weaver Street and Watergate Street on a postcard dated 28 August 1905. The upper level was once part of the Rows, but this was enclosed in 1711. It is likely this was around the time when the building became an inn. It was initially called The Star Inn, but later as it was so near to Chester's Port and Custom House it was renamed The Old Custom House. The writer of the card, Bill Preston, says, 'This is the old wooden hut where they sell good ale drawn by WP'. At that time the pub sold Wilderspool ales.

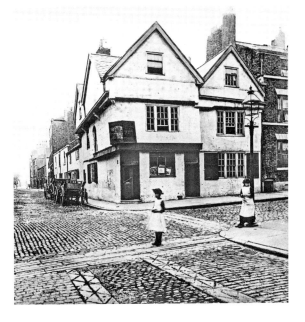

The Yacht Inn, c.1880. The inn stands on Watergate Street at the junction with Nicholas Street and the view looks up Nicholas Street towards the castle. The Yacht Inn with its premier position on the main street from the river to town was regarded as one of the best places to stay in Chester. The author of *Gulliver's Travels*, Jonathan Swift, stayed here while waiting for the boat to Dublin where he was Dean of St Patrick's Cathedral. However, he was not a happy man as the cathedral clergy, who he had invited to dinner at the Yacht Inn, snubbed him. He then wrote of Chester:

'Rotten without and mouldering within
This place and its clergy are all akin.'

The Yacht Inn was demolished to make way for the inner ring road in the 1960s.

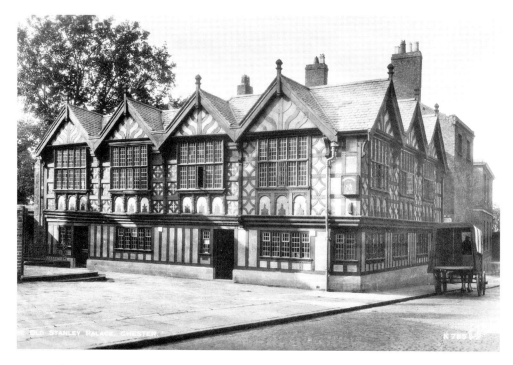

Derby House (now Stanley Palace), Watergate Street. The timber-framed house dates from 1591, when it was built as a townhouse for Sir Peter Warburton, MP for Chester. On his death in 1621, his daughter Elizabeth inherited the house. She was married to Sir Thomas Stanley, who then became Controller of the Watergate. At that time this was the major route to the city from the Port of Chester. Tolls were collected at the Watergate. The house has had many alterations over the years. The importance of the house was shown in 1911 when two tunnels were found during some building work. One of the tunnels led from the house to the Watergate and the other tunnel led to Chester Castle. There was an extensive restoration to Stanley Palace in 1935.

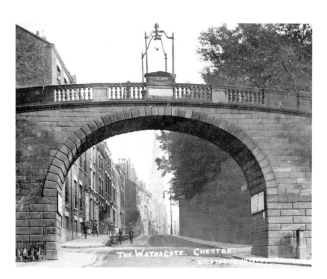

The Watergate on a postcard dated 31 October 1908. The spire of Holy Trinity Church can be seen in the centre through the arch. The River Dee once flowed past the Watergate. From 1621, the Stanley family collected tolls at the Watergate for cargo from ships docking at the Port of Chester. As the Dee silted up and larger vessels could not safely navigate the river, the importance of the port declined. The city purchased the Watergate from the Stanley family in 1788.

6

BRIDGE STREET

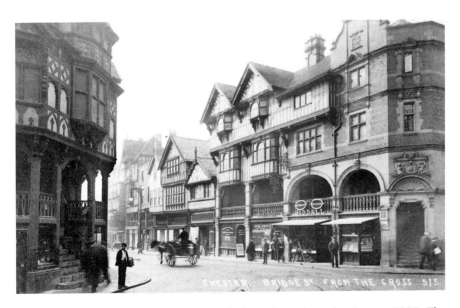

A view of the west side of Bridge Street looking down from the Cross, *c*.1920. The building on the right at No.4, with the sign displaying the prominent pair of pince-nez spectacles, is Siddall's Opticians. They were also makers of scientific instruments and umbrellas. Further down the street at No.8, by the newspaper stand, are the offices of Chester's weekly newspaper, the *Chester Courant*.

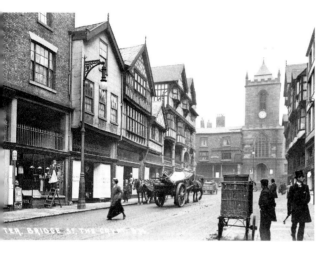

Bridge Street looking towards St Peter's Church, c.1920. The church dates back to the fourteenth century. It previously had an octagonal spire but this was taken down in 1783. The street is not busy: a gentleman in a top hat walks on the pavement on the right. The boy on the ladder on the left appears more interested in the activity on the street than in cleaning the shop windows. The lady crossing the road lifting her skirt may well have caught his attention! As the song says, 'In olden days a glimpse of stocking was looked on as something shocking'. How times have changed.

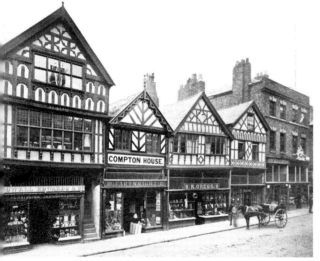

The west side of Bridge Street, c.1890. On the left at No.12 are the ironmongers, Powell Edwards & Co., who have the oldest crypt in Chester dating from AD 1230. Next to them at Compton House are the premises of Thomas Cartwright, who was a milliner, linen draper and hosier. A horse and carriage waits outside the shop at No.8 Bridge Street belonging to S. Robert Gregg. He was a rope and twine manufacturer.

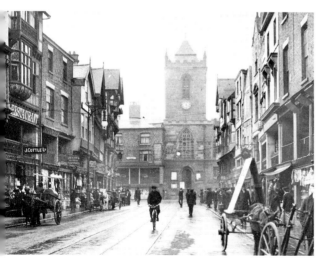

A rainy day in Bridge Street, c.1925. The pavements are busy and a lone cyclist rides down the street. On the west side of the street is the sign for James Cottle Ltd at No.20, who was a confectioner. Here too was the popular Plane Tree Restaurant and Tea Lounge, of which many Cestrians will have nostalgic memories.

There were a number of butchers' shops in Bridge Street, one of which belonged to John Horswill who was a pork butcher. He is shown here outside his shop at No. 3 Bridge Street on a postcard published by Will R. Rose, *c*.1910. He also had a shop at No. 34 Brook Street.

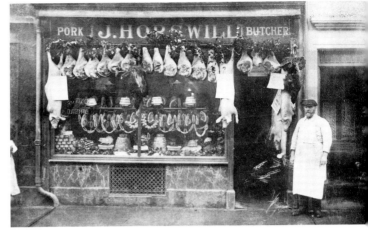

A troop of soldiers marching from Chester Castle up Bridge Street, *c*.1900. They are following a wagon packed with their equipment and it is likely that they are heading for the railway station. Perhaps they are going to a new training camp or possibly travelling to embark on a ship for passage to South Africa. Many Cheshire soldiers were involved in the Boer War which took place from 11 October 1899 to 31 May 1902.

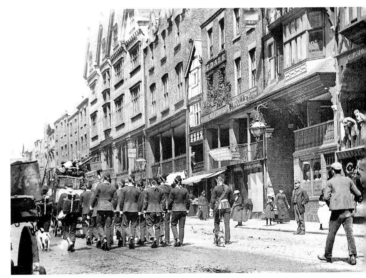

A crowded charabanc – probably on a special works outing or celebration – is pictured with the manager and restaurant staff outside the Hawarden Central Dining Rooms at No. 47 Bridge Street, *c*.1914. In the background a policeman and three soldiers have joined the photograph. The smartly dressed young boy sitting on the bonnet of the charabanc appears relaxed and may well have done this before. The signs on Bridge Street Row are for Dale's Piano and Organ Warehouse.

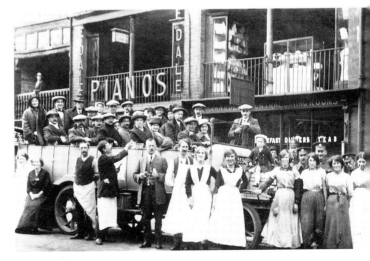

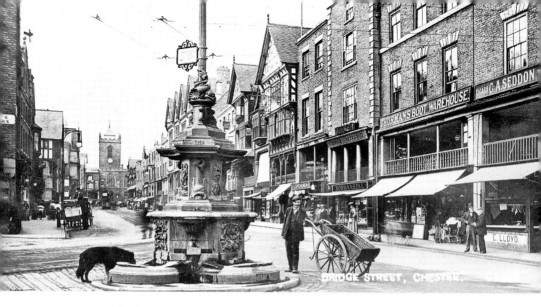

A view of the fountain in about 1910, which stood in Bridge Street opposite St Michael's Church at the junction with Grosvenor Street. The fountain was erected here in 1859 when the Mayor of Chester was the mill owner, Mr Meadows Frost. A dog is seen drinking from one of the horse troughs. On the left, tram tracks are curving into Grosvenor Street. On the right with their sun blinds opened are the premises of Edward Lloyd, butcher, Robert Knowles, greengrocer and Walter Duplock, chemist. Above them on Bridge Street Row are Seddon's tobacconists and Thurman's boot warehouse.

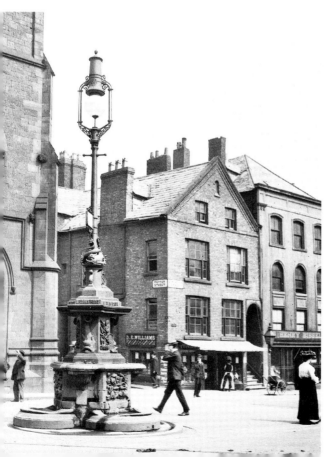

The fountain in Bridge Street, taken from an old magic lantern slide, *c.*1880. The fountain with its gas lamp was a great feature which stood there for over sixty years before the 'powers that be' decided it should be removed and replaced by a men's underground lavatory! The original Victorian street fountain, surely worth preserving, was destroyed and is now lost to posterity. The photograph also shows St Michael's Church, which stands at the junction of Bridge Street with Pepper Street. This medieval church was rebuilt around 1850 by James Harrison. Today it houses the Chester History and Heritage Centre. On the opposite corner of Pepper Street is David William's grocers shop.

An early photograph of the Falcon Inn, Lower Bridge Street, about 1870, when J. Boff was licensee. A policeman in early peeler's uniform with a hardened top hat and tailcoat stands outside the inn. The Falcon was originally built as a townhouse for the Grosvenor family in 1626. The building once had a row at first-floor level; however, this was enclosed to become part of the building in 1643. During the Civil War the family moved here from Eaton Hall. They kept the Falcon as their townhouse until the 1770s. After this time they continued to own the building but it was licensed as an inn between 1778 and 1878. The shop on the left of the inn is a boot and shoe manufacturers owned by Mr H. Walsh.

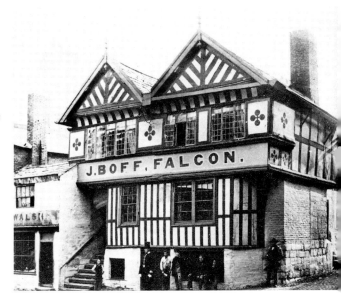

In a later view from about 1890, a stagecoach waits outside the renovated Falcon Inn, which had alterations made by John Douglas around 1879. The building was used as a temperance house known as the Falcon Cocoa House in the 1880s and later became a restaurant. The photo shows a group of men relaxing on the steps and pavement, perhaps waiting for opening time. On the right is Little Cuppin Street. The Grosvenor Bridge opened in 1833 and became the main road from Wales. This affected trade in Lower Bridge Street and many businesses struggled. When tolls for the Grosvenor Bridge were abolished in 1885, this made the problem worse. Many businesses closed and their buildings deteriorated. After a long period of closure, the Falcon was again restored around 1981 and reopened as a public house in 1982.

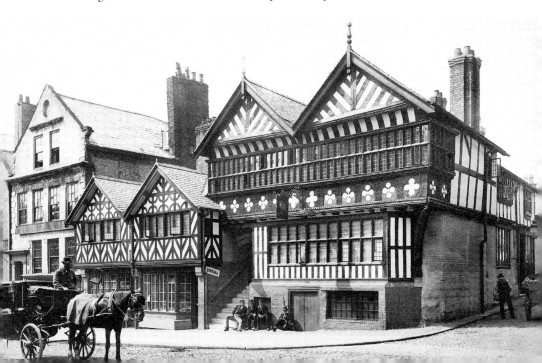

The Old Kings Head, which stands mid-way on the west side of Lower Bridge Street, c.1870. James Axon was the licensee. The house was built around 1550. Randle Holme, who served his apprenticeship for ten years with Thomas Chaloner, a distinguished arms painter and genealogist, became a tenant in 1598. He was the first of four successive Randles, father, son, grandson and great-grandson, who lived in the house from 1598 to 1707. All four were herald painters and genealogists, whose work is now in the National Archives in the British Museum. Randle No.1 was elected Mayor of Chester in 1633 and at the same time his son Randle No.2 was elected Sheriff. Randle No.1 died in 1659. Randle No.2 was elected Mayor in 1643 and prepared the defences for the city during the Civil War. His son, Randle No.3, recorded events and wrote a graphic account of the siege and capture of Chester by the Parliamentarians, which is a valuable detailed resource for historians researching the Civil War in the area. Randle No.4 was elected Sheriff of Chester in 1705. He died in 1707, the last of his line, and was buried in the church of St Mary on the Hill. It was not until 1717 that this old home of the Holmes was licensed as an inn. It traded successfully and the building was restored in the 1870s and again in 1935.

As with so many of Chester's ancient buildings the hotel has had sightings of ghosts, and a poltergeist reportedly visits the bedrooms from time to time. This postcard shows a particular 'Haunted Room' at the King's Head, where staff were afraid to work alone at night. The pub even featured in an episode of the TV show *Most Haunted*; however, its reputation has not been bad for business and it continues to attract visitors.

A postcard view dated 13 September 1907 looking up Lower Bridge Street towards St Peter's Church and the Cross. The tower of St Michael's Church marks the junction with Pepper Street. On the right of the photograph there is a Walker's Beer Barrel sign hanging outside the Feathers Inn. The black and white building next door is the Tudor House. Here is Frederick Quinn's bakery shop. Lower Bridge Street was not a good road for carriages; however, the cobbled street surface was helpful to horse traffic, which had to climb the steep road from the river.

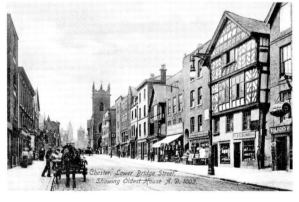

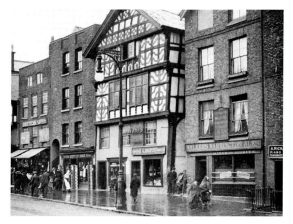

Left: A rainy day in Lower Bridge Street, *c.*1920. The Feathers Hotel no longer has its distinctive barrel sign although it continues to sell Walker's Warrington Ales. It is next to the narrow Hawarden Castle entry, which leads to Albion Street. Next to the entry is the black and white Tudor House, which dates from 1603 and is thought to be the oldest house in Chester. It was restored in 1907 and the photograph shows the building after restoration.

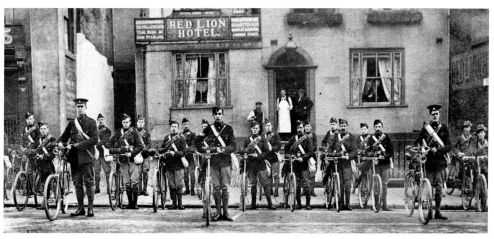

Above: The photo shows the 3rd Chester Boys' Brigade with their bicycles outside the Red Lion Hotel at No.7 Lower Bridge Street on Easter Monday 1904. The writer of the card says they had been training all morning. Public executioner William Marwood (1818–1883), who developed the more humane 'long drop' technique of hanging a condemned man, would stay at this hotel on his visits to Chester.

Right: Two barmen stand in the doorway of the Bear and Billet public house at No.94 Lower Bridge Street, *c.*1910. At that time, the licensee was Frederick Johnson. The timber-framed townhouse was built in 1664 for the Earls of Shrewsbury (the Talbot family), who collected the tolls from those using the Dee Bridge and entering Chester through the Bridgegate. One particular toll bailiff had a reputation for cruelty to his servants. He is said to have punished one of his maids by locking her in a small room for the day without food or water when he went off on business. However, he was held up and failed to return until days later, when he found that she had starved to death. Her ghost is still said to haunt the Bear and Billet.

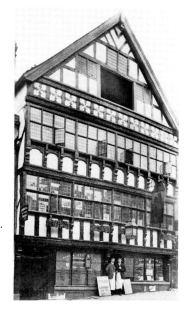

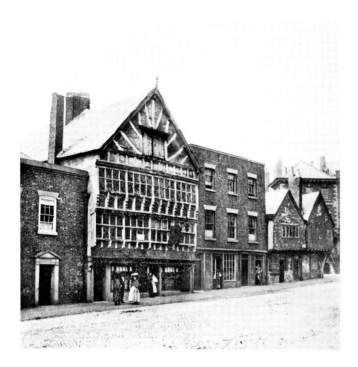

A quiet Bridge Street photographed from the Bridgegate, *c.*1890. In the 1896 trade directory the shops next to the Bear and Billet were George Caldwell's joinery and John Cain's boot and shoe shop. On the corner of Shipgate Street were Mr William Mason's refreshment rooms.

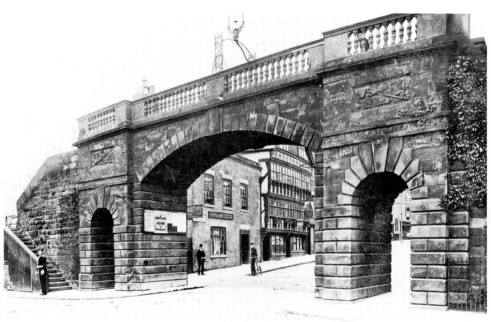

A view from Dee Bridge looking up Lower Bridge Street through the Bridgegate on a postcard dated 30 July 1906. The original Bridgegate dates back to 1120 but it had to be rebuilt around 1500. In the Civil War between 1644 and 1645, it was extensively damaged. The Bridgegate shown on the postcard was designed by Joseph Turner and built in 1781. On the left, next to the Bear and Billet Hotel, are the premises of the cab proprietor, Mr Walter Williams.

7

THE RIVER DEE

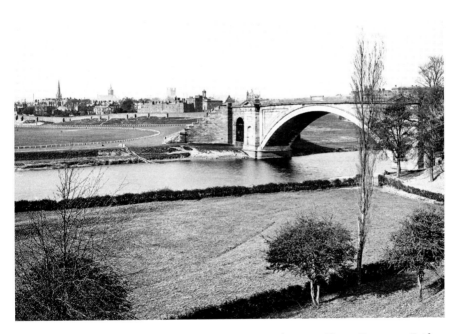

View from Curzon Park towards the Roodee, *c*.1880. The magnificent Grosvenor Bridge, which spans the River Dee, was designed by Thomas Harrison and built by Mr James Trubshaw between 1827 and 1832. The bridge was opened in 1832 by Princess Victoria, who would become Queen five years later. At that time, it was the largest single-span stone arch bridge in the world. The view also shows the sandstone militia buildings over the bridge in the distant centre with St Bridget's Church on the right. Both buildings have now been demolished.

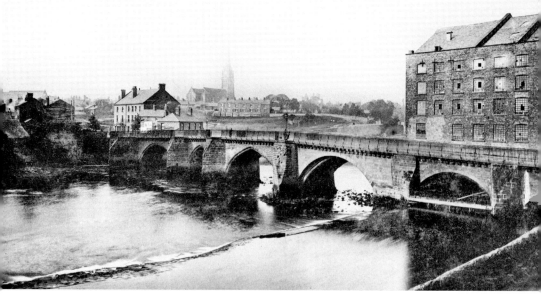

This photograph shows the old medieval Dee Bridge crossing the river towards Handbridge. The bridge, built of red sandstone and dating from the late thirteenth century, has seven arches of differing widths. In its early years, as the only Dee crossing, it was a magnet for Welsh invasions and in the early fourteenth century a tower gatehouse was built on the bridge and other measures taken to prevent Welsh raids. The weir, which was built in 1093, was a source of water power for the Dee mills. The mills, which were demolished in 1910, are shown on the right.

This photograph was taken from Castle Drive looking across the river toward Handbridge village and Greenway Street, *c*.1890. The church spire of St Mary Without-the-Walls, which dates from 1887, is prominent in the background. The large house on the right is Overleigh Manor. The salmon fishermen all lived in Handbridge and, in particular, Greenway Street. Net fishing for salmon was only permitted during the season on particular days of the week. On the far right of the photo are vertical wooden stakes on the river shore which were used to hold the salmon nets when they were drying out.

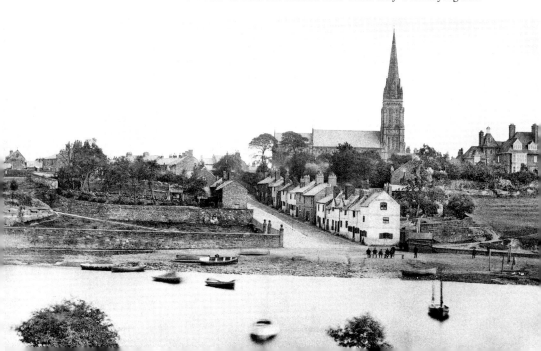

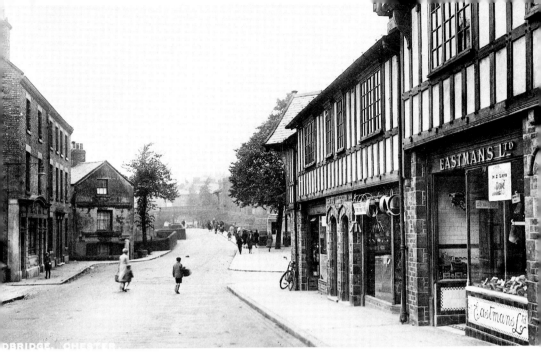

Handbridge village looking towards the Dee Bridge in the 1930s. The local shops in Handbridge were very popular. On the right is Mealing's hardware shop, which has a display of buckets hanging outside, and Eastman's butchers. On the left is the Ship Inn next to the Bridge Cottages, which are seen before the bridge. They include the cottage situated right on the river called Nowhere. It is believed that when the Beatles played at the Riverpark Ballroom in Union Street in 1962, or the Royalty Theatre in 1963 (see page 115), John Lennon heard about this cottage by the river and the name became the inspiration for his song 'Nowhere Man'. John had a Chester connection as his grandmother, Annie Millward, was born at the Bear and Billet Inn in Lower Bridge Street in 1873.

Mrs Bryan outside her terraced house at No.29 Browns Lane, Handbridge, *c.*1910. The suburb which housed many workers from the corn mills and tobacco works on the banks of the River Dee had been neglected for many years and was a poor area. At that time, the 'two up, two down' terraced houses had gas lighting and lacked good sanitation. Improvements were slow and a report by the Chester Medical Officer of Health in 1922 was critical of the housing in Handbridge.

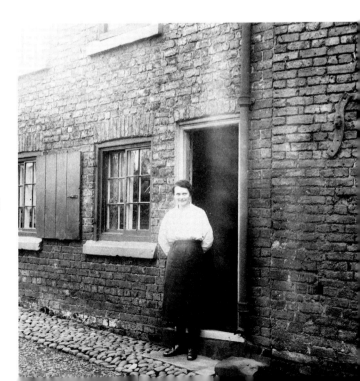

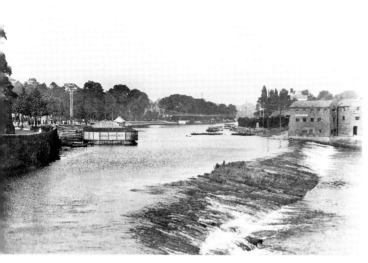

View of River Dee showing the weir and mills, c.1900. On the left are the Chester Floating Baths, which opened in 1877. A constant flow of water from the river flowed into the baths, which had a deep end and a shallow end. There were problems keeping the baths free of mud disturbed from the riverbed. It was an open-air pool which depended on the sun for heating; however, even in the summer the water could be very cold. For this reason, the baths were closed in the winter months.

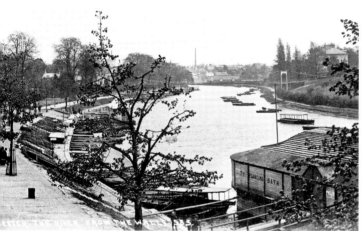

The River Dee viewed from the city walls. The entrance to the Floating Baths is on the right. The hours were restricted for lady swimmers, who had separate times from the men. When the new Chester City Baths designed by John Douglas opened in Union Street in 1901, there was no need for the Floating Baths and it closed. The following year, the whole structure was sold to Dobbins, a scrap metal dealer, for £20.

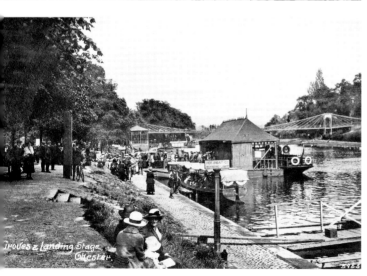

A busy day in summer at the Groves, seen here on a postcard dated 20 August 1923. A long queue waits to board the steamboat at the floating landing stage for a cruise to Eccleston Ferry. The trip would usually include a visit to the tea rooms at Eccleston and the Ironbridge at Eaton.

A view taken from an old lantern slide of the Victorian bandstand, which dates from 1913. On that day there was no band playing; however, some visitors are sitting on the banks by the river while others take a relaxing stroll. A steamboat is waiting to depart from the landing stage by the old suspension bridge.

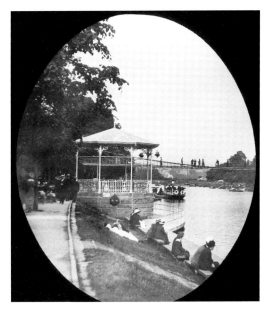

Below: This postcard, dated 30 June 1905, shows people gathered on the landing stage waiting to go boating on the River Dee. In good weather, it was a popular pastime and young men were always anxious to impress the ladies with their rowing prowess.

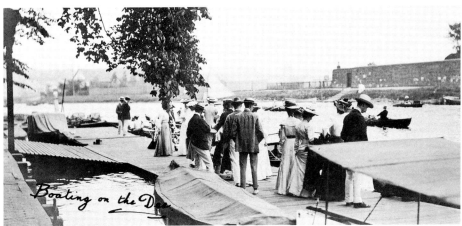

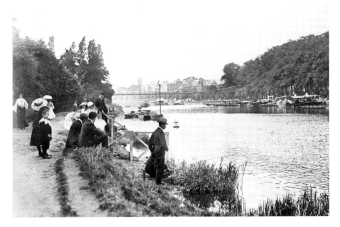

Left: Crossing the Queen's Park Bridge for a stroll on the riverbank was a good way to take some exercise and get away from the bustle of the city. This postcard shows the old suspension bridge and the city buildings viewed from a distance, *c.*1905. In the centre of the picture two men are fishing from the riverbank hoping to catch a salmon.

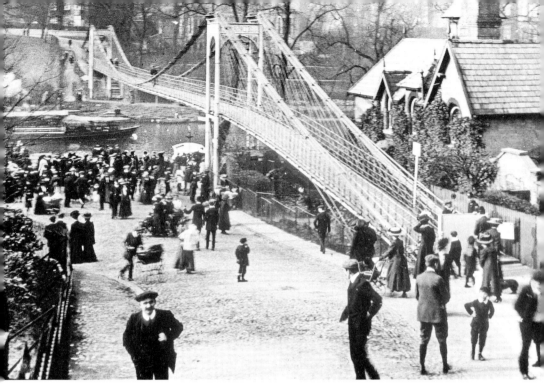

A view from a lantern slide shows a crowded river front and the old Dee Bridge, c.1890. A few people are walking on the old suspension bridge. Enoch Gerrard, the developer and proprietor of Queen's Park, employed James Dredge to build this pedestrian bridge in 1852 to connect the Groves riverside promenade to Queen's Park. In windy weather the walk across the bridge could be quite challenging. Young men would dive into the river from the middle of the bridge, which was 23ft from the river, without realising that there was not always great depth of water in the river at that point. The River Dee was a popular attraction, especially on Sundays; there were always large crowds on the Groves and visitors would enjoy boat trips on the river.

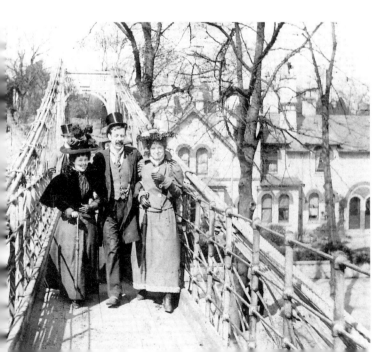

A stereoview card showing a family group dressed for the summer bank holiday walking across the original Queen's Park suspension bridge towards Queen's Park, c.1900. Only three people could stand abreast. This narrow bridge became unsafe and was demolished in 1922.

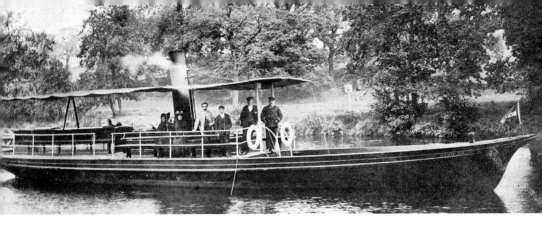

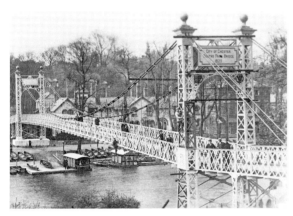

Above: The SS *Bend Or* sailing on the River Dee. The Dee Steamship Company had two red funnel steamers, the *Bend Or* and the *Ormonde*, named after racehorses owned by the Duke of Westminster. There were daily trips to Eccleston Ferry and the Iron Bridge at Eaton. The fares to Eaton were eight pence single and 1*s* (twelve old pence) return. The passengers could enjoy music on the boat from the Moss Brothers Trio and would usually have refreshments at the tea house at Eccleston.

Above: When the old suspension bridge became unsafe and had to be demolished, the City Engineer, Charles Greenwood, designed a new bridge, which was built in 1922. Here workers are shown adding the finishing touches to the new bridge in early 1923. The painters at work on the bridge appear to have no platforms or harnesses – health and safety was not such a concern at that time!

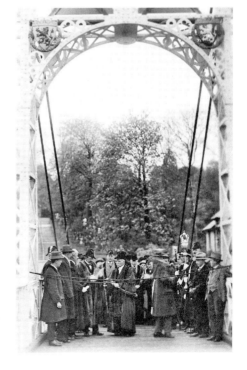

Right: This photograph shows the opening of the new wider suspension bridge on 18 April 1923. The Mayor of Chester, Mr Arthur Wall, is cutting the rope on the entrance to the bridge from the Groves. The bridge, which cost £8,000, was much stronger than the old bridge and was said to be able to hold over 1,000 people. It is a fine structure still connecting the Groves and Queen's Park today.

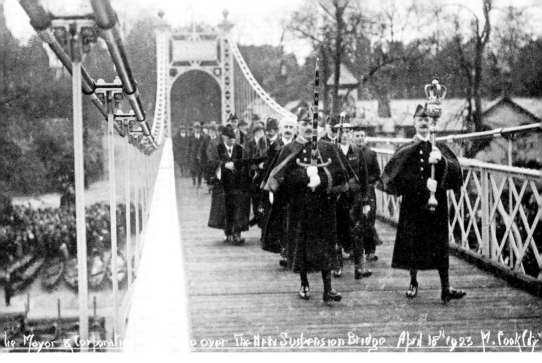

he Mayor & Corporati ... over The New Suspension Bridge April 18ᵗʰ 1923 M. Cook (t

The official party in procession, led by bearers of the ceremonial mace and sword. The large group – including the Town Clerk, Mr J.H. Dickson; the Sherriff of Chester, Alderman W. Carr; and the Mayor, Mr Arthur Wall – are seen crossing the new suspension bridge from the Groves to Queen's Park. Large crowds can be seen on the riverbank on the left.

A postcard view of the idyllic Groves with the row of lime trees by the river. On the left is the boathouse for the Grosvenor Rowing Club, which was designed by Thomas Lockwood in 1877. The men standing by the trees are waiting to hire out rowing boats, although business seems slack. At the far end of the path are the wooden gates shown in the photograph opposite, which are now the entrance to the Boathouse public house.

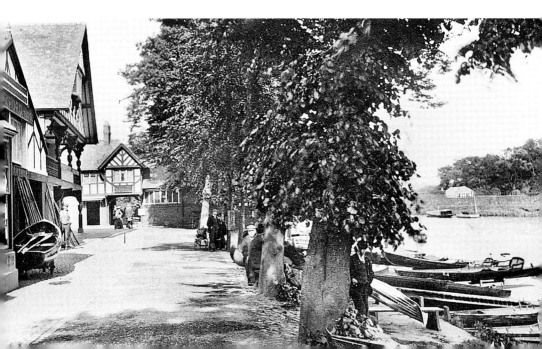

The wooden gates at the entrance to Aikman's Gardens on the Groves, *c*.1900. Sara Aikman traded here as a florist and also had a beer house around 1840. The sign over the gates is advertising the Chester Boat Company. They had boats for sale or hire and were also licensed to sell ales and tobacco.

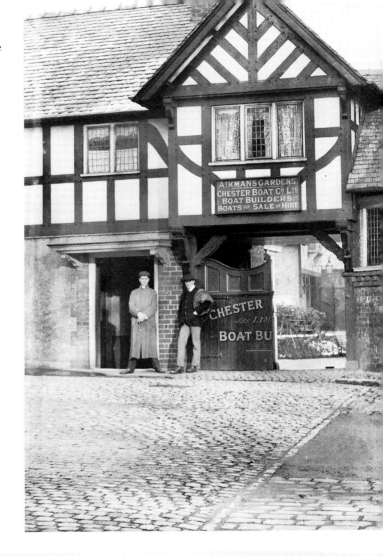

The River Dee above Chester, viewed from the Meadows, *c*.1910. The pleasure steamer is taking passengers to Eccleston. On the right is the spire of St Paul's Church in Boughton. The church was designed by John Douglas and built in 1876. On the far right is Lower Waterworks House.

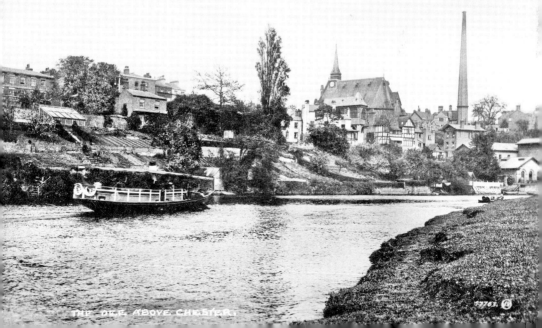

The Meadows have always been a popular place for Cestrians to enjoy views across the River Dee and get some fresh air and exercise. It is an idyllic, peaceful place and hopefully it will stay that way. This photograph shows a group of children out walking on the Meadows in about 1905

This postcard, dated 12 July 1939, shows rowers on the River Dee receiving instruction from a coach with a megaphone. The card was written by George Cunningham, who was the licensee of the Red House Hotel at that time. The hotel began trading in the mid-nineteenth century. It has a superb position with a garden running down to the riverbank, with boat moorings and access from the road at Dee Banks. In 2006, a large restaurant extension was built overlooking the river and, at the time of writing, the Red House and river garden continue to be a popular destination for Cestrians. The historic Dee Mile swimming race, held in June each year and first competed in 1922, starts at the Red House and finishes at the suspension bridge. The real distance is a mile and a quarter.

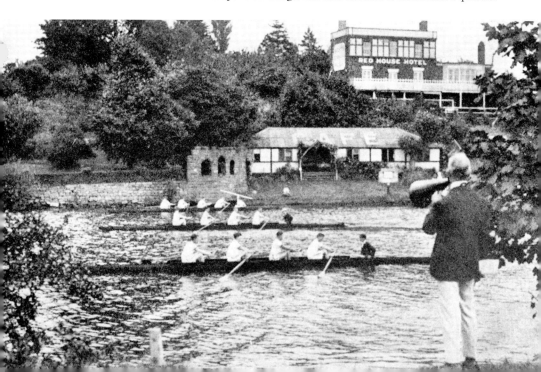

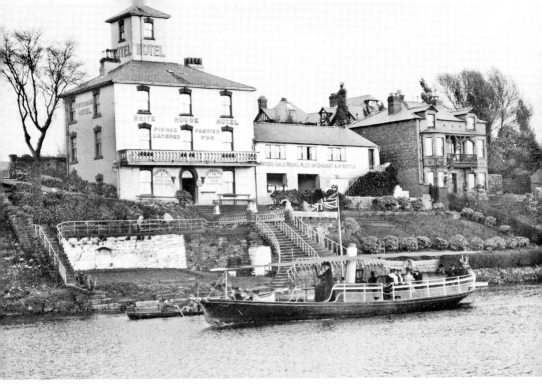

This view, taken from a lantern slide, shows the SS *Toronto* passing the White House Hotel on Dee Banks, *c.*1900. The steamer had a white funnel and was owned by the Chester Boat Company. The White House Hotel was built in 1868 by Mr Edward Tasker, who was the first licensee. The hotel had its own jetty and visitors could arrive by boat for picnics or use the road from Dee Banks. The sign on the right of the hotel advertises 'Yates Gold Medal Ales'. The Cestrian Rowing Club was based at the hotel for many years. Unfortunately, the hotel fell into disrepair in the 1960s and was knocked down in 1971. It was replaced by Riverside Court, a modern block of apartments, in 1982.

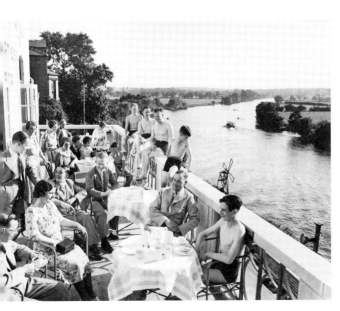

A family gathering on the balcony at the White House Hotel in the 1930s, shown in a photograph originally published in the *Liverpool Daily Post*. It was the perfect spot to dine and enjoy the sunshine. This popular hotel had great views of the river and the Meadows. There are many examples of historic or memorable buildings in the city being lost for commercial interests, but it is still surprising that a hotel in such an ideal spot should not have prospered.

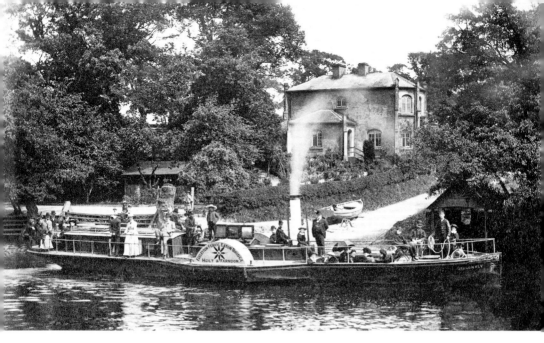

The *Dragonfly* at Eccleston Ferry, *c*.1880. After visiting the tea rooms, the passengers have returned to the steamboat for the cruise to Chester. There has been a ferry across the River Dee at Eccleston for over 900 years. The Grosvenor family received the tolls. The boathouse seen on the bank, which had popular tea rooms, was damaged in a flood in 1887 and had to be replaced.

A later view of Eccleston Ferry showing the Dee Steamboat Company's boat *Bend Or* (see page 67) on a postcard dated 5 July 1908. The steamboat together with its companion steamer the *Ormonde* had an eye-catching red funnel. The Tudor-style black and white building, which replaced the flooded boathouse, is seen in the centre of the picture. On the left are the chain pulleys for the flat-decked Eccleston Ferry which operated at that time to carry passengers across the River Dee.

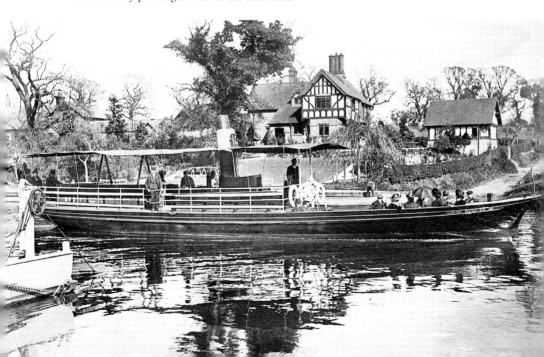

8

THE PARK,
ST JOHN'S CHURCH,
THE NEWGATE AND
CHESTER CASTLE

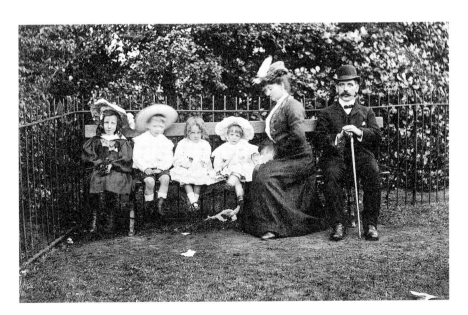

A delightful family group posing for a photograph in Grosvenor Park, *c*.1910. All are dressed in their Sunday best. This quiet area enclosed by railings lies near St John's Church and overlooks the suspension bridge on the River Dee.

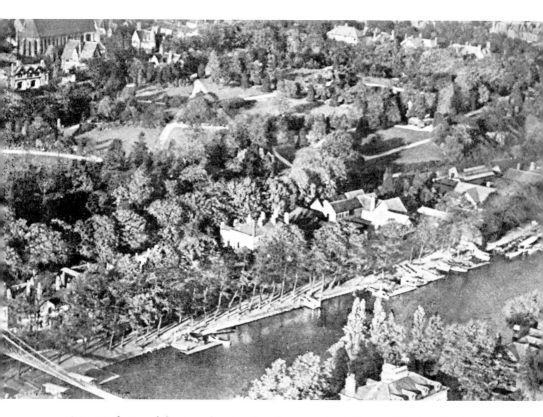

A postcard view of the river showing the old suspension bridge and the tree-lined groves with boat moorings. Behind the row of houses is Grosvenor Park stretching towards the city. At the top left of the photo is St Werburgh's Church in Grosvenor Park Road. In 1867, Richard, the Second Marquess of Westminster, donated 20 acres of land to the city to make a park for the citizens to enjoy health and recreation. The park was designed by Edward Kemp. He studied under Sir Joseph Paxton, who had appointed him as his superintendent in 1854 to lay out a park at Birkenhead. This was the first public park in Britain and its design inspired New York's Central Park. Under the guidance of Paxton, Kemp developed his talent and his design for Grosvenor Park made it one of the finest parks in Victorian England.

Right: An early photograph of St John's Church taken from the riverbank, *c.*1890. Between 1075 and 1095 this was the cathedral for Peter, the first Norman bishop of the united dioceses of Lichfield, Coventry and Chester. Peter designed and started building a grand cruciform cathedral but, in 1095, the bishop's see was transferred to Coventry. The church remained a cathedral but fell into disrepair until Henry VIII's Dissolution of the Monasteries, when it became St John's Parish Church.

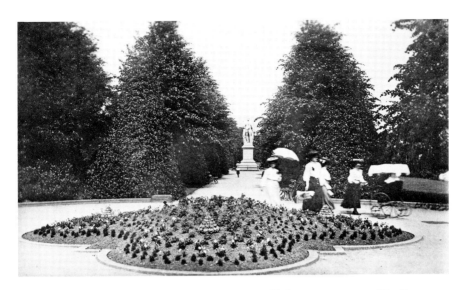

This postcard, dated 10 July 1915, shows a group of ladies enjoying a stroll in Grosvenor Park. The baby in the pram is well protected from the sun. The imposing statue of Richard, Second Marquess of Westminster – which was erected in 1869 by the townspeople to thank him for the gift of his land for the park – is shown in the distance. An inscription on the base of the statue reads:

> The Generous landlord
> The Friend of the Distressed
> The Helper of all good works
> The Benefactor to this City.

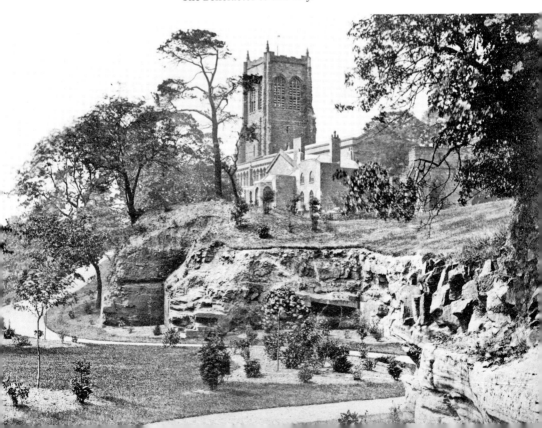

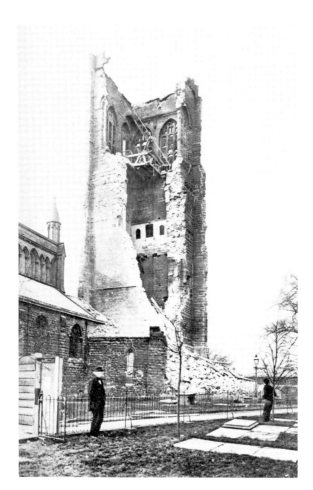

St John's Church tower collapsed on Good Friday, 15 April 1881. Following this disaster, the tower had to be demolished and it was replaced by a small bell tower and a new porch designed by John Douglas in 1882, which remains the entrance to St John's Church.

A group of children enjoy a sunny day in Grosvenor Park. Behind the railings are the ruins of St John's, which give only a limited idea of how extensive and impressive the buildings of the original cathedral were.

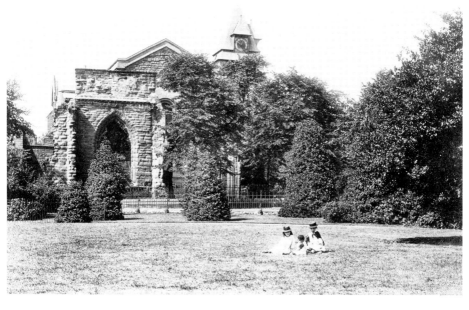

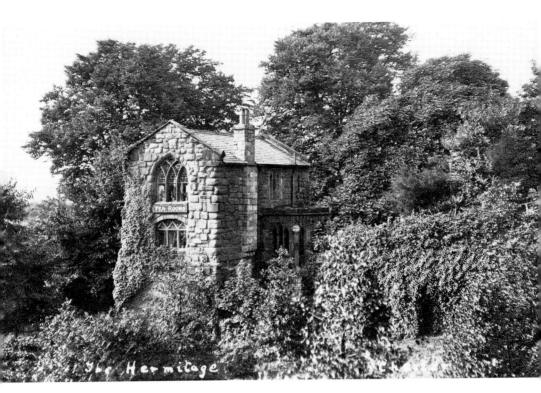

The Hermitage

Close to St John's Church at the junction of Souter's Lane and the Groves is the Anchorite's Cell, built of sandstone and dating from the mid-fourteenth century. It was built as a place of retreat for solitary monks. An old legend says that in 1066, after the Battle of Hastings, a wounded King Harold fled north with his wife and took refuge as a hermit in this cell. He was hoping to recover from his injuries and then take a boat to Ireland; however, he was too ill to travel and spent his last months alone in the Anchorite's Cell. After his death, it is said that his wife returned from Ireland to stay in Chester. The story appears unlikely but Harold's body was never displayed after the battle by the Normans. Is it possible that Harold did not die at Hastings, but in fact evaded capture and escaped northwards, ending up in Chester? This view of the Anchorite's Cell or Hermitage is shown on a postcard dated 21 July 1910.

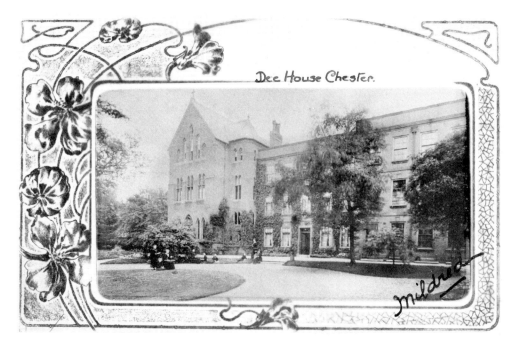

Dee House Chester.

Mildred

Dee House Convent on a postcard dated 1 February 1909. The house was built around 1730 for John Comberbach, who had been Mayor of Chester. Unfortunately it was built over the southern part of the site of a Roman Amphitheatre. The house was purchased by the Catholic religious order of the Faithful Companions of Jesus (FCJ) in 1854. They developed it into a successful convent school for girls. In 1925, it was taken over by the Ursuline Order who continued to manage this girls' grammar school until the convent closed in 1976. At the time of writing, the building has been empty since the early 1990s and has fallen into disrepair. Hopefully this Grade 2 listed building will be demolished so that the whole of the Amphitheatre can be fully excavated.

Opposite top: This photograph shows a smart group of students in uniform pictured in the grounds of the FCJ Convent, *c.*1910. Many people in Chester were sad to see the closure of the convent as the ethos and education of the girls was much admired.

Bottom: A peaceful scene at the Wolf Gate taken from a lantern slide, *c.*1900. The view is taken from Pepper Street, with Newgate Street on the left. The Wolf Gate was built in 1760 and although unused since the building of the Newgate, it is now the city's oldest gate. A cyclist has just ridden on the cobbles through the Wolf Gate. The sign on the wall on the right shows that it is a stand for six cabs. The building on the left is the premises of James Storrar & Son, veterinary surgeons. The practice had to move when the building was demolished in the 1960s.

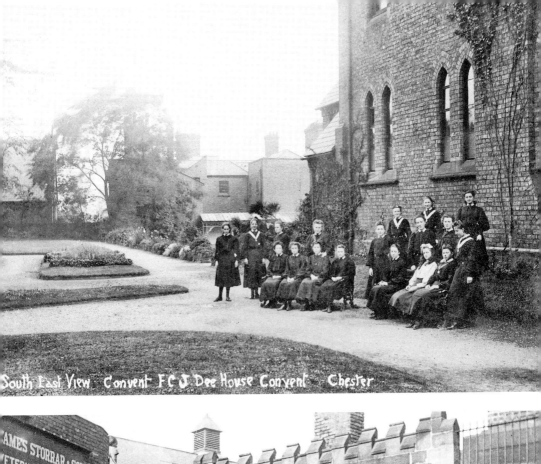

South East View. Convent F C J Dee House Convent Chester

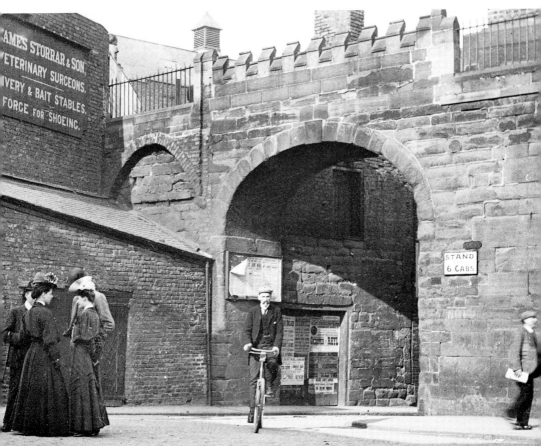

The Newgate was designed by the architect Walter Tapper and his son, Michael. It was built of red sandstone and was opened on 3 October 1938. The tall building on the left of the Newgate was the old Lion Brewery in Pepper Street, which had closed in 1902. The Wolf Gate is on the right.

A horse and carriage wait outside the Grosvenor Museum in Grosvenor Street, *c.*1890. The architect for the museum was Thomas M. Lockwood and it was opened on 9 August 1886 by the Duke of Westminster. It has a fine Ruabon brick front with large front windows and a terrace on top. Today the museum has unique Roman Galleries which tell the story of the Roman fortress of Deva. The building next to the museum is the Chester Savings Bank, which is now a restaurant.

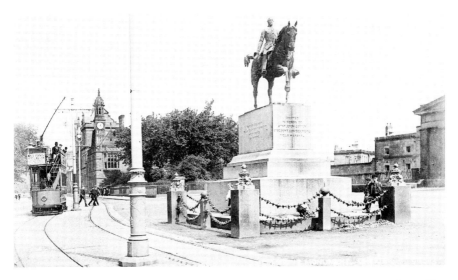

This postcard, dated 12 July 1907, shows tramcar No.11 entering Grosvenor Street. The impressive statue of Field Marshal Viscount Combermere (1773–1865) on his horse stands in the centre. The sculptor was Baron Marochetti and the monument was placed here in 1865. The viscount, who served under Wellington and rode with the cavalry at Salamanca in Portugal, is best known for his capture of Bhurtpore in India. He was Provincial Grand Master of Chester Freemasons. The entrance to Chester Castle is seen on the right.

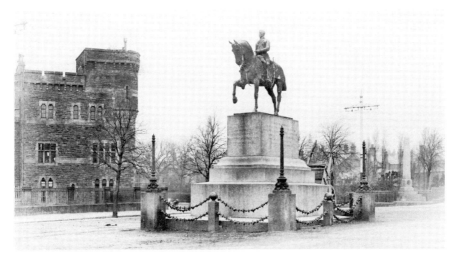

This postcard, dated 2 May 1904, shows the Militia Barracks on the left. They were designed by Thomas Penson and were built around 1858. The Barracks housed the soldiers and their families who were garrisoned at Chester Castle. In the centre, surrounded by railings, is the equestrian statue of the First Viscount Combermere. On the far right stands the obelisk designed by Thomas Harrison and dedicated to the nonconformist minister and author Matthew Henry. It originally stood in the churchyard of St Bridget's Church, but was moved in the 1960s to stand on the roundabout by Chester Castle.

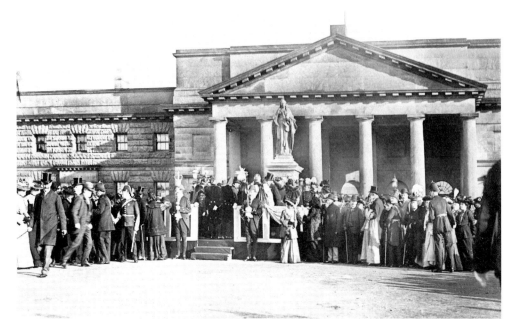

Crowds gather at the unveiling of the statue of Queen Victoria on Chester Castle Forecourt by the Lord Lieutenant of Chester, Earl Egerton, on 17 October 1903.

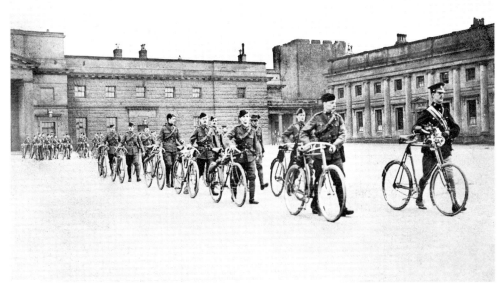

Soldiers were trained to ride bicycles as it was a speedy form of transport. Here an infantry Volunteer Battalion with their bicycles are shown gathered on Chester Castle Forecourt on a postcard dated 6 April 1904. The writer of the card says, 'Frederic marching forth from Chester Castle on last Saturday morning'.

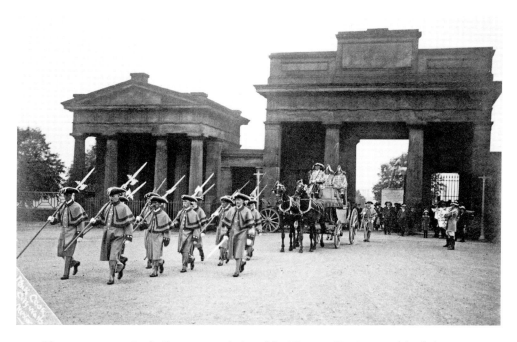

The entrance to Castle Square was designed by Thomas Harrison and built between 1811 and 1815. It was modelled on the Acropolis in Greece. This photograph by Mark Cook shows the coach carrying the Judge and High Sheriff with the Javelin Men leading the way through the entrance into the castle forecourt and heading towards the Assize Courts, c.1910.

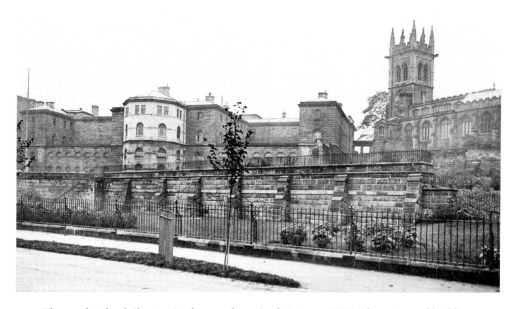

The south side of Chester Castle, seen from Castle Drive, c.1905. The octagonal building housed the County Gaol and overlooked the prisoners' exercise yard. The church tower of St Mary on the Hill is on the right.

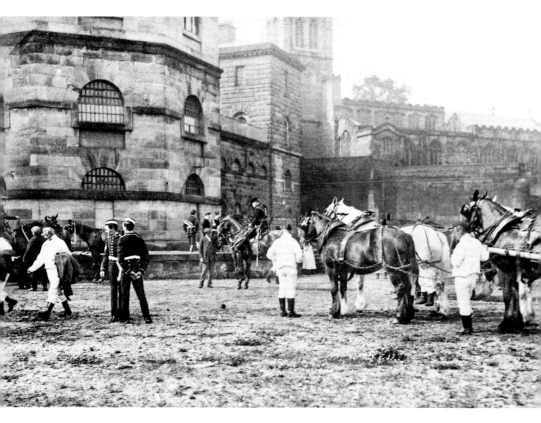

Soldiers from the Cheshire Regiment on exercises in the castle yard on a postcard dated 16 May 1905. The octagonal County Gaol which was designed by Thomas Harrison is on the left. The gaol was closed in 1884.

9

CITY TRANSPORT

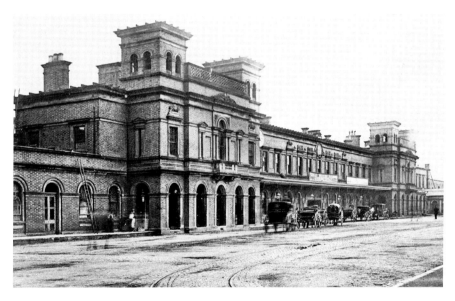

This photograph taken from a lantern slide of around 1880 shows coaches and carriages waiting outside Chester General Railway Station. The sign for the Great Western Booking Office is above the entrance. The station was a joint station shared by the Chester & Holyhead Railway, the Chester & Crewe Railway, and the Birkenhead Railway. The station has an Italian look with its long frontage and imposing towers. It was designed by Francis Thompson and built by Thomas Brassey (1805–1870) in 1848. In fact, Thomas Brassey was born at Buerton and went to the King's School in Chester (see page 41). During his lifetime he became one of the most important railway builders, undertaking successful major projects in many countries. At the time of his death it was said that he had built one in every 20 miles of railways in the world!

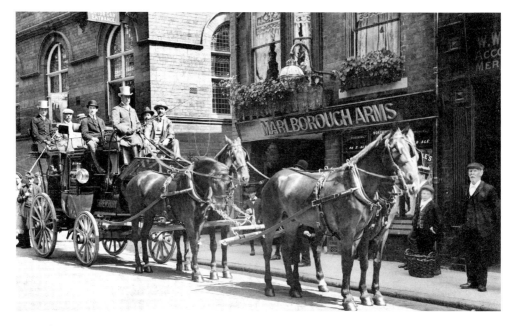

The Shrewsbury Coach waits outside the Marlborough Arms on St John's Street in this postcard dated 16 August 1908. The coach was pulled by four horses and could carry up to six passengers inside. Stagecoach travel was expensive but the coach also carried passengers on the roof, who paid a cheaper fare. However, the future direction of travel is shown by the sign hanging on the wall of the Blossoms Hotel (upper right), which shows the way to the hotel entrance for motor cars.

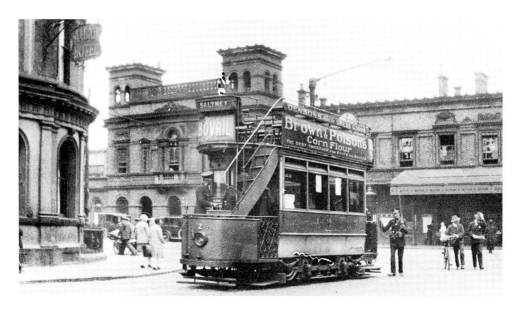

Taxi cabs waiting outside Chester General Railway Station, *c.*1920. Tramcar No.2 is waiting outside the Albion Hotel (now the Town Crier) ready to pick up passengers for the city and Saltney.

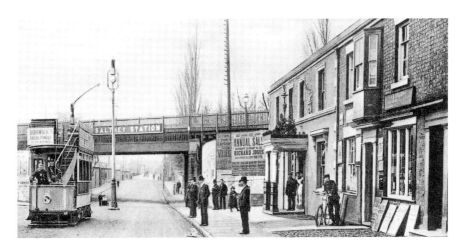

Tramcar No.2 at the Saltney terminus with the GWR railway bridge behind. The Saltney Station was on the Shrewsbury, Oswestry and Chester Junction Railway, which was amalgamated with the Great Western Railway in 1854. The station at Saltney opened on 4 November 1846 and closed on 12 September 1960. The advertisement for Richard Jones's 'Annual Sale' on the right dates to January 1905.

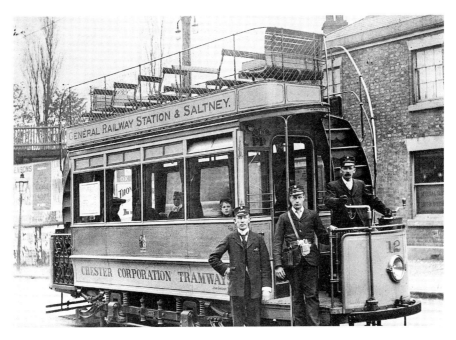

An early photograph of tramcar No.12 at the Saltney terminus. The crew and the inspector pose for the photographer. A few passengers on the lower deck sit waiting. The staircase to the upper deck is quite steep. For all Chester trams the upper deck was open to the elements as it was thought that adding a roof would stop the trams going under the Eastgate. There was a low 'decency board' which showed the tram's route and also protected ladies ankles from public gaze! The bench seats on the upper deck, which do not look very comfortable, slope backwards.

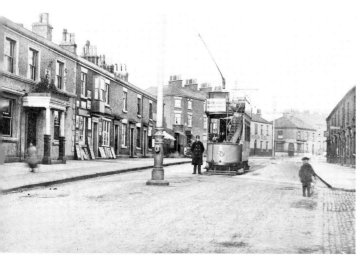

View from the railway bridge of tramcar No. 3 at the Saltney terminus. On the left is the Curzon Arms public house, which is next door to the post office and newsagents. The boom above the tram has been swung for the return journey which would take the tram into the city via Hough Green, then over the Grosvenor Bridge, along Bridge Street, Eastgate Street, Foregate Street and City Road to Chester General Railway Station.

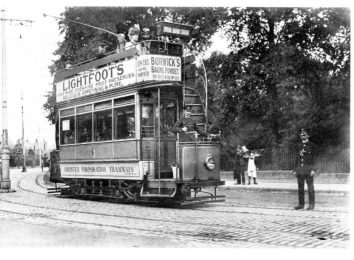

View of tramcar No. 2 at Hough Green heading for the Grosvenor Bridge, c.1910. The sign indicates that the tram is going to Chester General Railway Station. Advertising boards have now replaced the 'decency boards' along the upper deck. Because of Chester's narrow streets the width of the tram lines was restricted to three and a half feet, which allowed for double tram tracks. However, there was still a need for single tram tracks under the Eastgate and at the Cross.

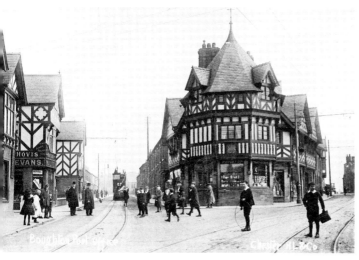

Boughton Post Office, designed by John Douglas, is shown is on this postcard dated 22 April 1907. It is the black and white building at the junction where the Boughton tram line divides into Tarvin Road on the left and Christleton Road on the right. The photographer has attracted lots of attention, including the boy with the stick and hoop in the centre of the photo. A tram is shown heading up Tarvin Road towards the terminus at the Bridge Inn.

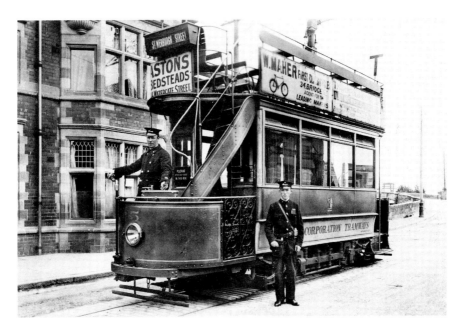

The Boughton route, which ran from St Werburgh Street, opened in November 1906. The postcard shows tramcar No. 3 with the driver and conductor at the tram terminus on Tarvin Road outside the Bridge Inn, c.1907. The destination on the indicator box is St Werburgh Street and the 'T' on the rear of the tram indicates Tarvin Road. The message on the postcard reads, 'We have just arrived back from our walk – the country looks very beautiful. I am going to post this card at the General Post Office'.

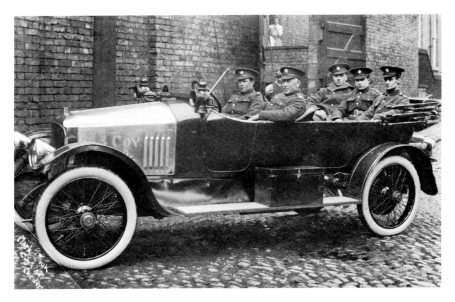

A postcard showing a group of five officers from Chester Castle in a Vauxhall First World War military staff car in Chester, c.1914. The photograph was taken by Mark Cook, who had a studio on the city walls.

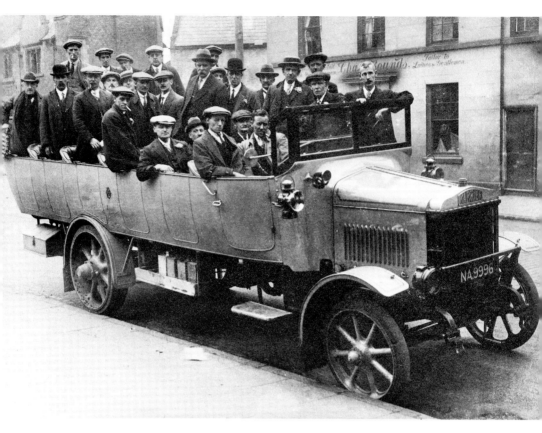

A group of workers on an outing in a fully loaded Karrier Charabanc, *c.*1920. They are parked outside the premises of Charles Bounds in Grosvenor Street, whose sign says he is a 'Tailor to Ladies and Gentlemen'. The open-topped vehicle was great for travelling and sightseeing when the weather was fine, but not so good when it was raining.

10

PEOPLE AND EVENTS

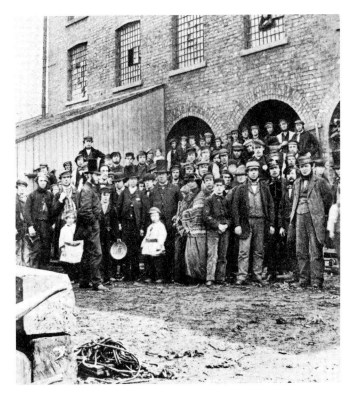

A group of workers and managers in top hats are shown outside the Lockwood and Farrimond Factory in a photograph dated 1862. This builders and timber merchants ran the saw-mills at Egerton Street in Chester and employed many local people, including some youngsters.

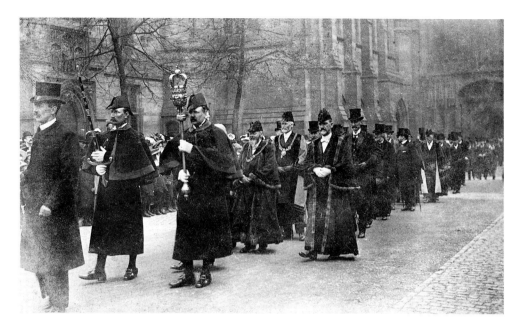

Mr T.F. Brown of the 'Browns of Chester' family (see page 23), who lived in Curzon Park, was elected Mayor of Chester on 9 November 1906. This postcard shows him returning to the Town Hall after Divine Service in the cathedral on Sunday, 11 November 1906.

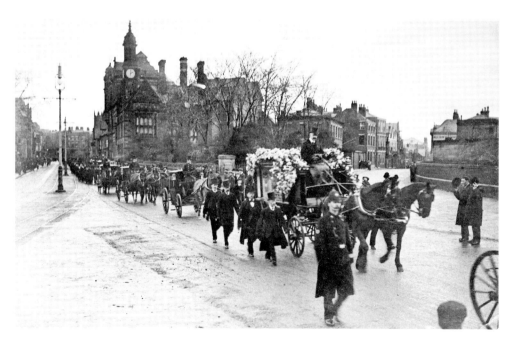

Mr Brown's term in office was very short as he died, aged only 56, following a bout of pneumonia on 2 January 1907. His funeral service was held on 5 January 1907 at the cathedral and this photograph shows the large funeral procession leaving Grosvenor Street to cross the Grosvenor Bridge for the burial at Overleigh Cemetery in Handbridge.

The royal visit to Chester by the Prince and Princess of Wales on 6 July 1908. Their carriage is shown in the Town Hall Square. This was their first official visit as the Earl and Countess of Chester.

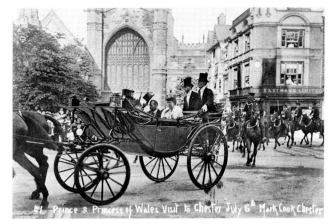

The royal carriage is shown waiting outside the decorated Town Hall. Inside, the Prince and Princess received an address of welcome to the city from the Mayor of Chester, Mr John Jones. Firemen from the Earl of Chester's Volunteer Fire Brigade line the steps of the Town Hall. This fine photograph was taken by Mark Cook.

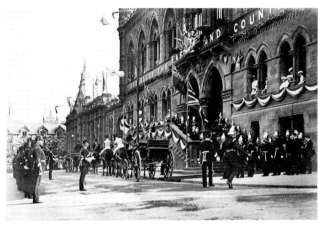

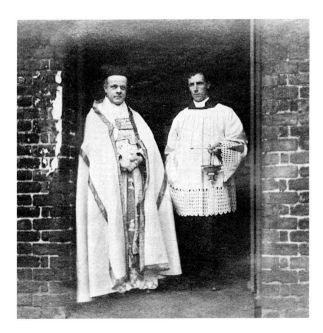

Canon Chambers and Father Hayes awaiting the arrival of King Alfonso of Spain for Mass at St Werburgh's Church, Grosvenor Park Road, on 1 December 1907. King Alfonso XIII (1886–1941) had married Princess Victoria Eugenie (known as Ena), the granddaughter of Queen Victoria, on 31 May 1906. The King was in Chester visiting the Duke and Duchess of Westminster at Eaton Hall. While staying there the King enjoyed hunting with the hounds and playing polo. At home in Spain he also followed football and was a patron of many 'Royal' ('Real' in Spanish) football clubs, which still prosper today.

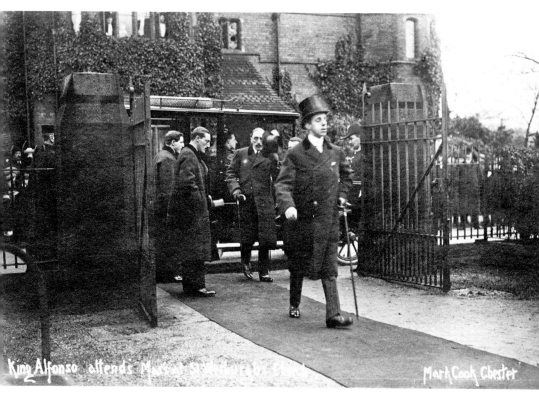

King Alfonso attends Mass at St Werburgh's Church Mark Cook Chester

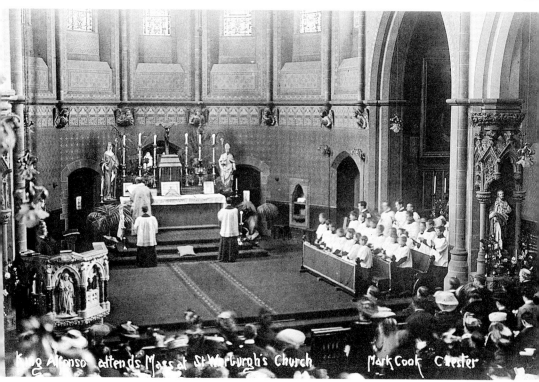

King Alfonso attends Mass at St Werburgh's Church Mark Cook Chester

Opposite top: Cheering crowds watch from Grosvenor Park Road as King Alfonso walked on a red carpet to the door of St Werburgh's Church for the celebration of Mass at 11 a.m. He was accompanied by three Spanish lords including the Duke of Alba, who would later become General Franco's Ambassador in London in 1931. The church was packed with parishioners and many people had to stand.

Bottom: An interior view of St Werburgh's Church, which was designed by Edmund Kirby and had its official opening on 13 July 1876. It has fine gothic arches and tall stained-glass windows. The high altar of onyx and marble was built in 1926. The church was originally designed with a 200ft spire, but unfortunately financial constraints stopped any development. This photograph was taken by Mark Cook and shows the celebration of the Mass by Canon Chambers. The King sits on the right in the front row. The choristers were on the right of the altar.

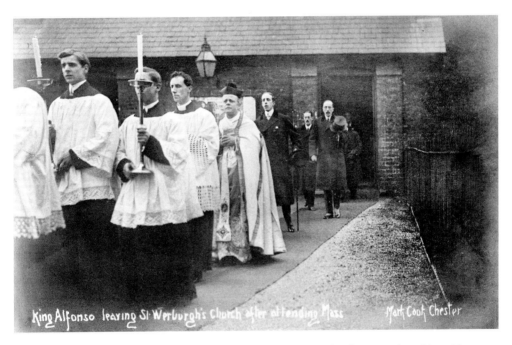

King Alfonso and his party leaving St Werburgh's Church after attending Mass. The Spanish National Anthem was played as he left the church. The *Chester Courant* reported that King Alfonso was delighted with the friendliness of his reception in Chester and said it was like being back in Spain. He left a generous donation to the church building fund. The future for this King was eventful. Spain remained neutral in the First World War, but Alfonso became seriously ill during the 1918 flu pandemic and was lucky to survive. Later, in part due to economic problems and the rise of nationalism, the Spanish Civil War followed and he was forced to leave Spain in April 1931. He abdicated his rights to the Spanish throne on 15 January 1941 and he died in Rome on 28 February 1941.

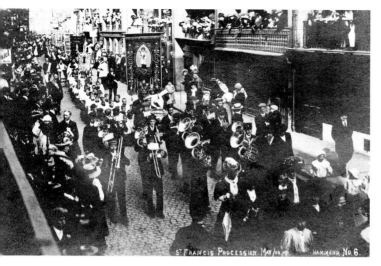

St Francis Church May Procession on 31 May 1908, with the brass band playing and large crowds watching from the Rows in Watergate Street. There had been celebrations in the previous May, when the parishioners of St Francis Church in Grosvenor Street held the first Catholic May Procession in Chester since the Reformation.

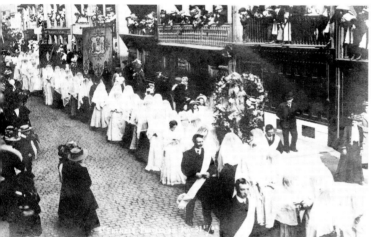

Another view of the May Procession. The writer of the postcard says, 'This is only a small part of the procession which included priests, men, women, boys and girls from St Francis's Parish walking around the town singing hymns. A great time was enjoyed by all'.

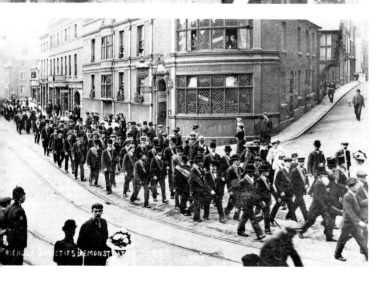

The Friendly Societies Demonstration on Sunday, 20 June 1909. The large procession is shown passing the King's Head Hotel on the corner of Grosvenor Street and White Friars.

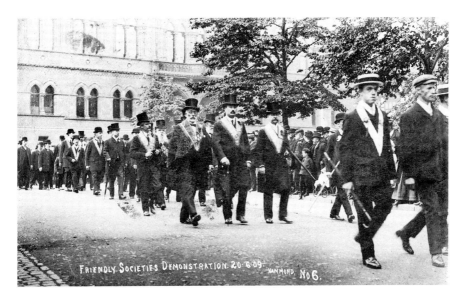

The procession is shown here in Town Hall Square heading towards the cathedral for the Annual Friendly Societies Service. A large crowd has gathered in the Square to watch the parade. The writer of the postcard says, 'There was a good turn out and the weather kept fine'.

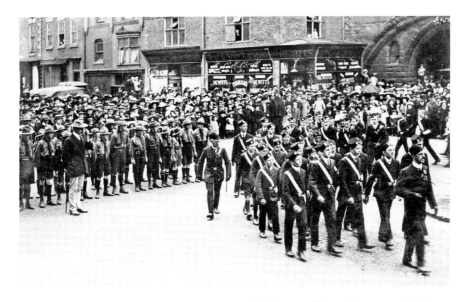

Chester Boys' Brigade and the Boy Scouts parade from Northgate Street into the Town Hall Square on Empire Sunday, 23 May 1909. The pavements are crowded with spectators standing four or five deep outside Hewitts Boot Stores and in front of the Abbey Gateway. The next day was Empire Day which was a day of celebration for all. Queen Victoria died on 22 January 1901 and the first Empire Day day was celebrated on 24 May 1902. Children were given the day off school so that they could take part in marches, maypole dances, concerts and parties. Everybody enjoyed singing patriotic songs showing loyalty to the King and British Empire.

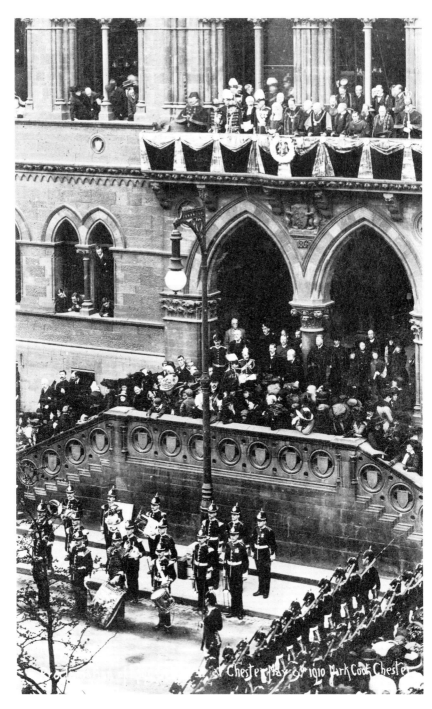

On the evening of Monday, 9 May 1910 the Town Hall Square was crowded and the Town Hall balcony packed with dignitaries for the proclamation of His Majesty King George V by Alderman D.L. Hewitt, the Mayor of Chester. The people were still mourning the death of Edward VII and the balcony at the Town Hall was draped with purple and black velvet with a white wreath in the centre.

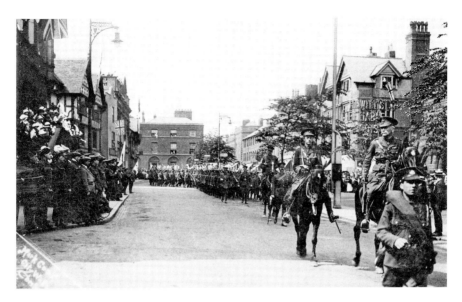

The streets are crowded with spectators and flags fly from several windows as a parade of soldiers from the Cheshire Regiment march past the Mayor and local dignitaries on the balcony and steps of Chester Town Hall. The date of the photograph, taken by Mark Cook, is unknown, but it is thought that this is the occasion of 'The Call to Arms' in September 1914. There is a good view of Northgate House before it was demolished and replaced by the Odeon Cinema.

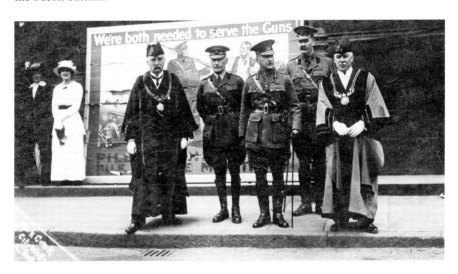

Another photograph by Mark Cook shows the Mayor of Chester, Sir John Meadows Frost, on the right with officers from the Cheshire Regiment outside the Town Hall. Later they would attend a packed meeting in the Music Hall to continue the 'Great Recruiting Campaign'. The crowd were entertained with patriotic songs and given stirring speeches from the platform exhorting the young men to volunteer for army service. The Music Hall was originally an old chapel until it was rebuilt in 1855. It stands between St Werburgh Street and Northgate Street and was a fine meeting hall and also a cinema from 1915. It closed in April 1961 and the building is now occupied by Superdrug.

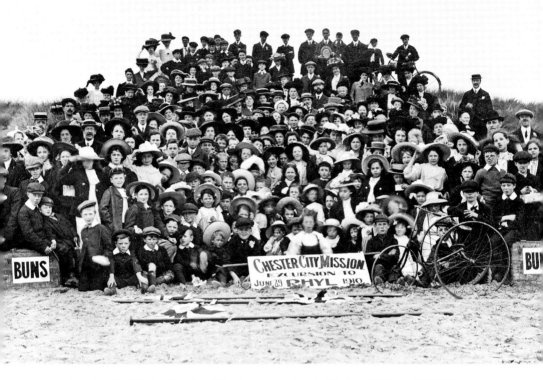

Chester City Mission Sunday School on an outing to Rhyl on 29 June 1910. This was a popular annual event and the children were always taken on an outing to the seaside. Everyone was in their Sunday best and most wore hats. The flags on the sand were used in the parade and the boxes labelled 'buns' were for the picnic on the beach. The writer of the postcard, which was sent to a friend in Broughton Road, Saltney, said she had a very pleasant day.

Opposite bottom: Beating the Bounds of the City of Chester on 11 October 1913. This ancient ceremony in Chester dates back to the 1500s; however, the ceremony only took place sporadically, often depending on the preference of the Mayor. The boundaries were described in the Charter issued by Edward, the Black Prince, to the City of Chester on 9 March 1354. The photograph shows the procession led by the Mayor Hugh Dutton leaving the Groves. They had returned by boat from Heronbridge. At each boundary stone a boy from the Bluecoat School had to strike the stone with a special rod. During the walk, new dated boundary stones were set up wherever needed. This was not a regular event and in fact the ceremony was not repeated until 7 October 1972.

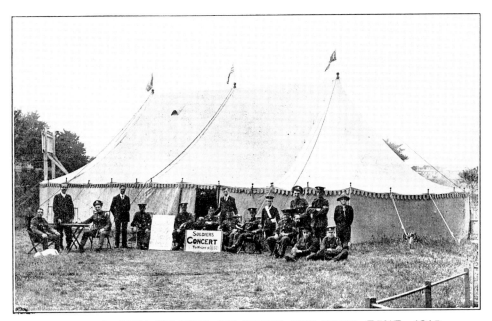

CHESTER CITY MISSION SOLDIERS' WELCOME TENT, 1915.

Above: During the First World War Chester City Mission erected a 'Welcome Tent' near to Chester Castle Barracks where returning soldiers were given hospitality. It was very popular and the postcard shows a group of soldiers meeting there in 1915.

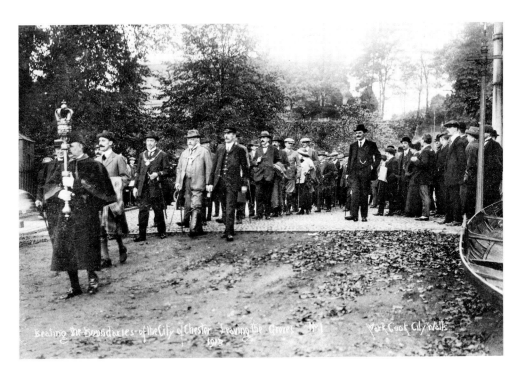

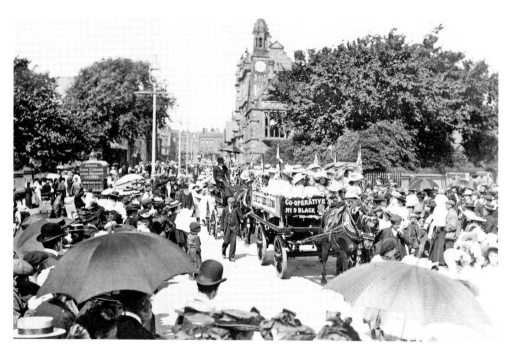

Above: Crowds throng the streets to watch the children's procession on the Co-operative Fête and Gala day, *c.*1910. The horse-drawn lorry has just passed the Grosvenor Museum and is heading for the Roodee. It carries a group of young girls dressed in white and all wearing splendid bonnets. The shire horse is also dressed for the occasion and is wearing decorative horse brasses.

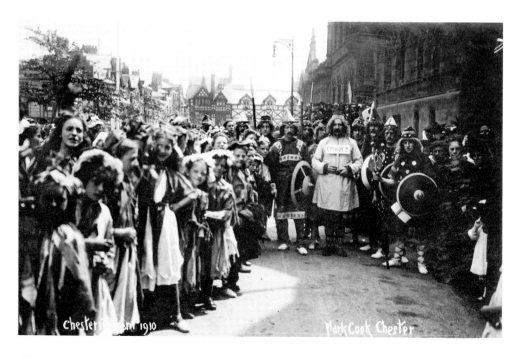

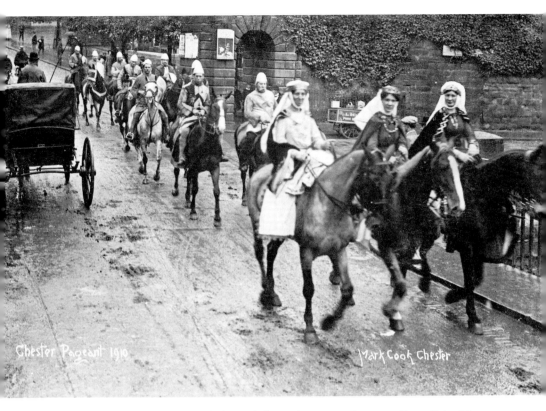

Above: A part of the procession ride through the Bridgegate on the way to Eaton Drive. The Chester Pageant was very successful and had wide support from the people of Chester. Mr Yerburgh, the MP for Chester, was very active in support of local events. He played the part of Lord Byron in the pageant. Lady Arthur Grosvenor and her family also took part; she dressed as a Saxon Queen and her children were dressed as princes and princesses.

Left: The Chester Pageant took place from 18 to 23 July 1910 at Eaton Drive. This postcard shows a part of the procession which has gathered in the Town Hall Square. The young men are dressed in Viking costumes. The pageant was opened by Hugh Lupus, the Duke of Westminster, who was the Pageant President. Edwin Drew wrote poems for the pageant. The first verse of his main poem is as follows:

> Hail! Rare Olde Chester in thy splendid age,
> You bend in thought o'er the historic page,
> And rises all the romance of thy past;
> A story deep, unique, enthralling, vast.

The pageant lived up to this splendid preface. It had a grand Introduction which was followed by eight episodes showing important events in Chester's history. At the conclusion of the performance everybody gathered for a magnificent Grand Tableau.

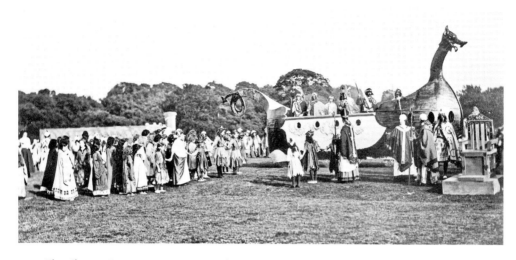

The Chester Pageant was a spectacular event which was performed each afternoon by around 3,000 players. Visitors flocked to the shows and the enclosures for the spectators were filled to overflowing. This postcard shows a scene from episode No.11, which celebrated the arrival of King Edgar at Chester in AD 973. He was rowed up the Dee by seven Tributary Kings.

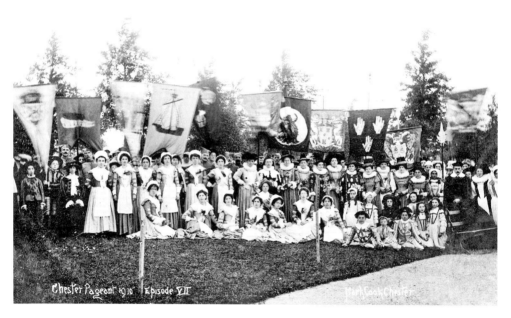

There were performances each afternoon and for evening entertainment there was illumination of the river bridges and a firework display. The programme also included a fancy-dress ball and concerts by the Band of the Royal Marines. This postcard shows a group of girls in costume displaying various banners. They all appeared in episode No.VII of the pageant, which showed King James on his visit to Chester. The girls performed as Morris Dancers in Midsummer Revels to welcome the King. The photograph was taken by Mark Cook, although the official Pageant photographer was T. Chidley.

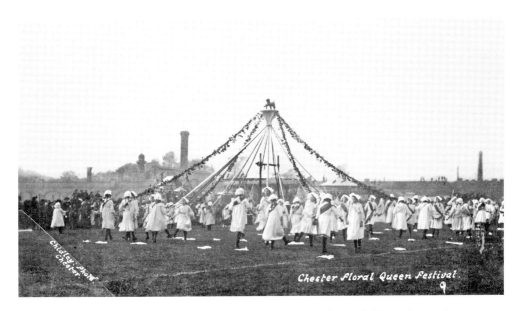

Chester Infirmary Fête, also known as the 'Mayors Fête', was held on the Roodee on 2 October 1912. This postcard shows a large group of girls dressed in white. Each girl wears a sash and they are dancing around the maypole. The fête had a full programme of events which included Morris Dancing, the Chester Floral Queen Festival and a Military tournament.

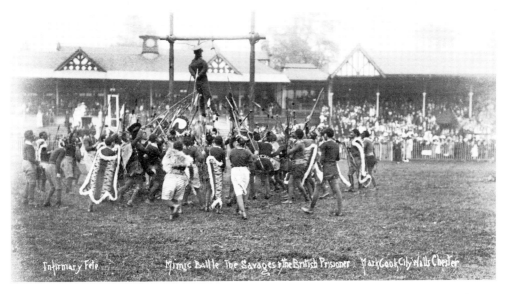

There was a large crowd at the fête which packed the stands on the Roodee. This postcard shows a part of the entertainment which depicted a 'Mimic Battle' which took place after savages had captured a British prisoner. The military mounted an attack on the group of savages and the soldier was rescued just as he was about to be hung. It would not be politically correct today but history is often uncomfortable.

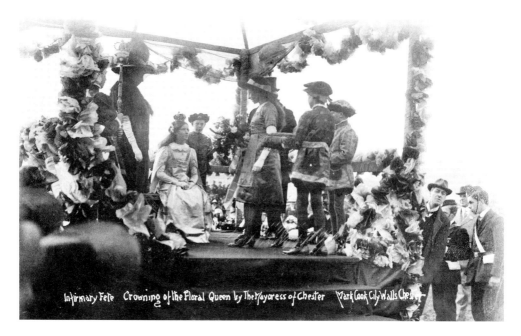

Infirmary Fête Crowning of the Floral Queen by The Mayoress of Chester Mark Cook City Walls Chester

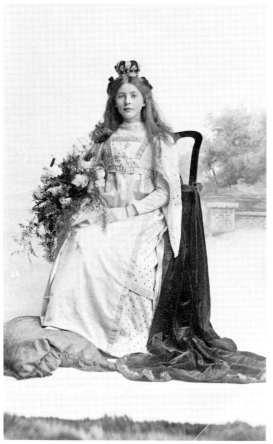

Chester Infirmary Fête on 2 October 1912, showing the crowning of the Chester Floral Queen by the Mayoress of Chester. The stage is decorated with garlands of flowers and the Floral Queen is shown being presented with a bouquet of flowers.

The Chester Floral Queen in 1912 was Miss Violet Brooks. She is pictured wearing her crown and holding her bouquet. The photograph was taken by Chidley in his studio in St Werburgh Street.

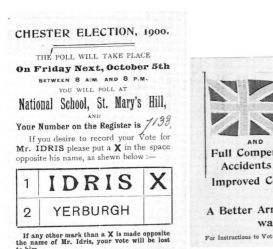

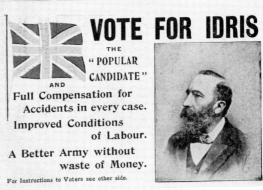

Chester Election, 5 October 1900. The poll was a direct competition between Mr Yerburgh and Mr Idris (whose advertising card is shown). However, on voting day he was not successful and Mr Yerburgh won the Chester seat.

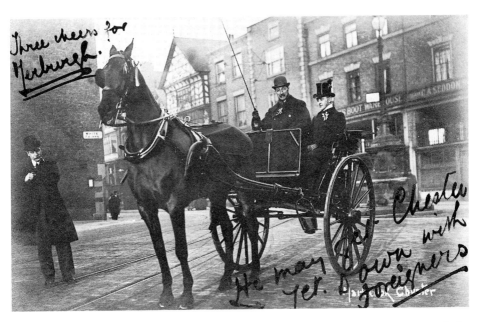

Mr Yerburgh canvassing in the 1906 General Election. He is pictured in Bridge Street with the Fountain behind. The comments on the postcard, dated 23 January 1906, written on the front of the card by the writer certainly show where her sympathies lay! 'Three cheers for Yerburgh – he may get Chester yet – down with foreigners.' Unfortunately, the writer would have been disappointed as Mr Yerburgh was defeated in the election by Mr Alfred Mond, a Liberal, who won with a majority of only forty-seven votes.

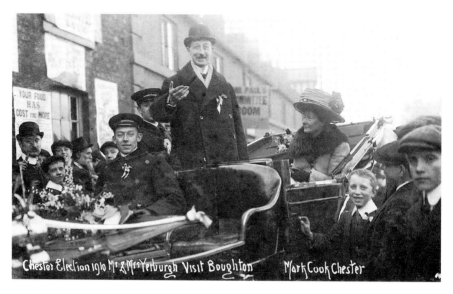

Chester Election 1910 Mr & Mrs Yerburgh Visit Boughton Mark Cook Chester

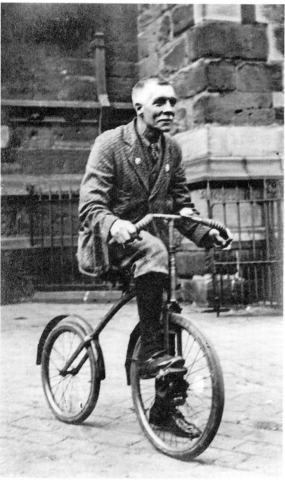

Mr Yerburgh and his wife canvassing in Boughton for the General Election of January 1910. This time he regained this marginal seat, beating the Liberal candidate Mr Edward Paul with a majority of 202 votes.

The cyclist in this 1920 photo was a familiar figure on Chester's streets, for the writer of the postcard says that the bike can be seen anytime at Dunnings Café in Northgate Street, Chester.

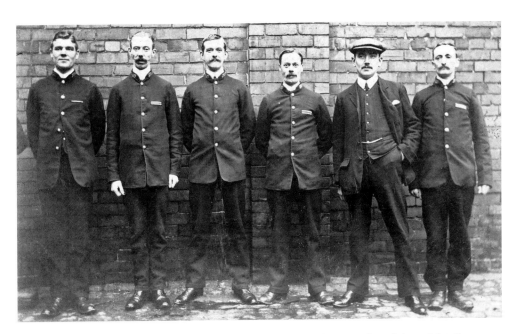

Chester postmen in the Sorting Office Yard, City Road. They are, from left to right, Tom Bell, Jack Roberts, George Whitlow, Alf Jones, Arthur Mullins and Joe Bailey. The postcard was sent on 30 November 1910.

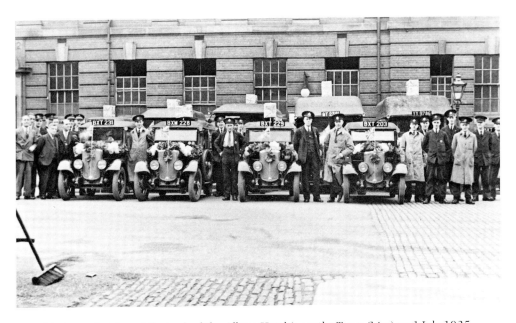

Photograph taken at the back of the Albion Hotel (now the Town Crier) on 1 July 1935, celebrating the inauguration of a new and cheaper parcel post service which started on that day. The cars – with parcels on their roofs and decorated with flowers and flags – are shown lined up with their drivers and staff from the Sorting Office. The Superintendent of the Sorting Office at that time was Mr William White.

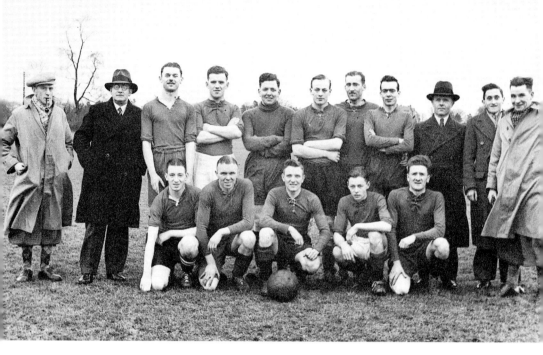

The Chester Post Office football team, who played against a team from Shrewsbury Post Office in the 1920s. The writer of the card says that Chester won the game by five goals to nil.

During the First World War, and in the years following, people were encouraged to grow their own fruit and vegetables. There was much competition and this postcard from about 1920 shows a fine display of potatoes grown by staff at Chester Railway Station. The prize-winning plates of potatoes are being inspected by the stationmaster, Mr McNaught, who is standing on the far right of the picture.

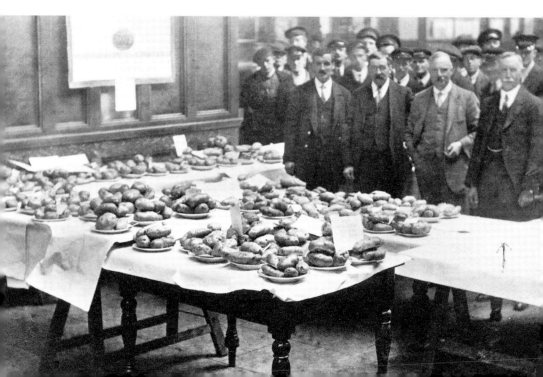

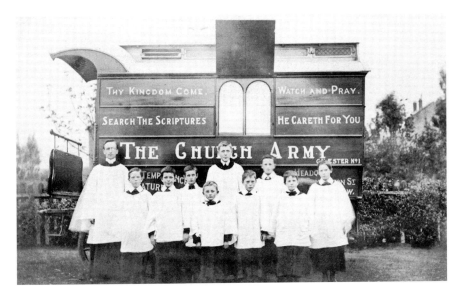

The Church Army was established by Wilson Carlile in 1882. Its mission was to train ordinary working Christian people to share their faith by studying the gospel and helping others by doing social work in slums and prisons. They used mission caravans and by 1914 there were seventy caravans in operation nationwide. There were two vans in Chester which were both horse-drawn and this postcard shows the No.1 van pictured with a group of choristers.

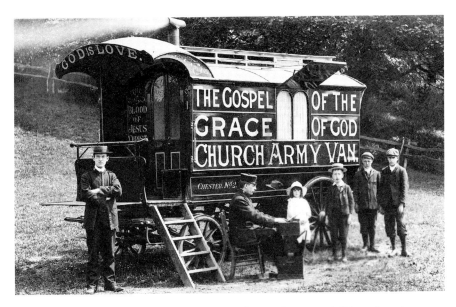

The Chester No.2 van. The vans covered the Chester district and did good work among the poor. The preacher would stand on the platform at the front of the caravan to talk to the assembled crowd. They were all encouraged to spread the Christian message by their words and actions. There was help for the unemployed and during the First World War the missions provided much needed help and recreation facilities for the soldiers.

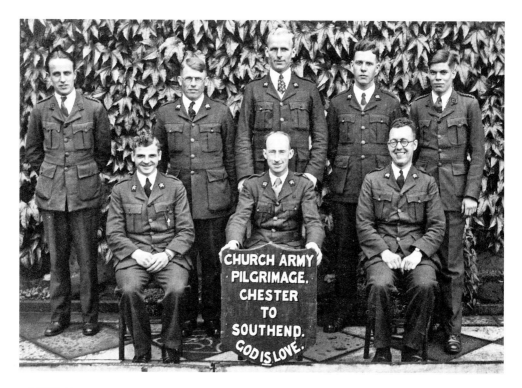

From the 1920s onwards, groups of evangelists travelled on missions all over England hoping to attract new followers. They preached the gospel and the importance of temperance. This photograph shows the Church Army Pilgrimage which travelled from Chester to Southend in 1939. From left to right, back row: C. Buckmaster, T. Nash, R. Sanger, H.J. Mitchell, R. Leng. Front row: A.J. Tatnall, E. Fortune, A.J. Tudball.

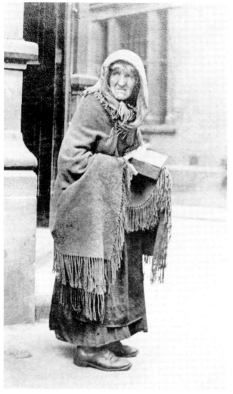

A familiar Chester character is shown begging on the streets, c.1910. Jack, the writer of the postcard to his cousin M. Mason in Accrington, says, 'Do you remember this lady in Chester – is she like old mother Simpson who told your fortune?'

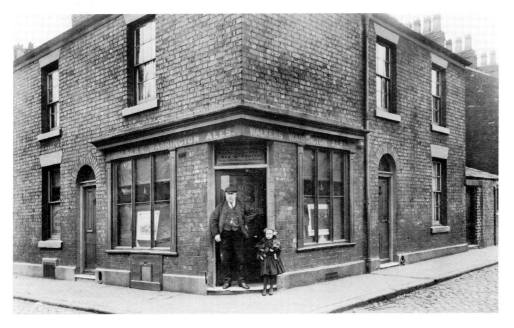

William C. Worrall, licensee of the Mechanic Arms at 10 Church Street, Chester. The public house was on the corner of Talbot Street and sold Walkers Warrington Ales. At that time, Newtown was home to many Chester workers who lived in the terraced two-up-two-down houses. The neighbourhood was a strong community and the local pubs were an important meeting place. The Mechanics Arms attracted many regular customers from Newtown. Mr Worrall kept the pub with his wife Margaret.

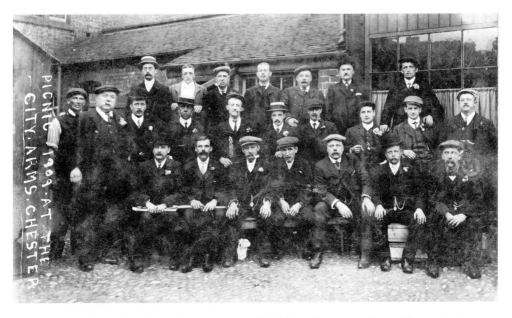

A group of regulars from the City Arms in Frodsham Street are pictured here prior to going on a picnic in the summer of 1909.

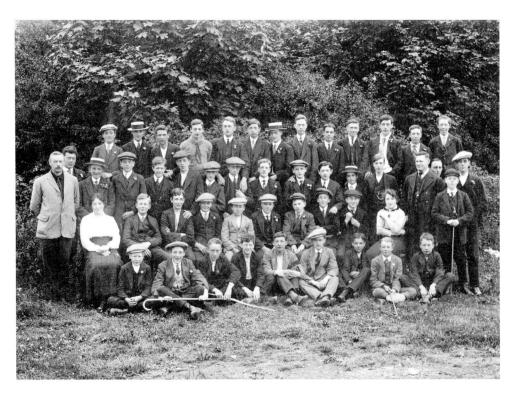

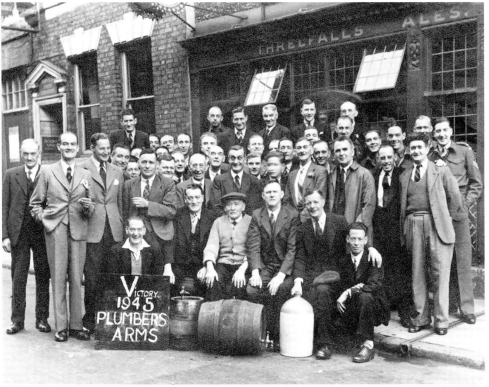

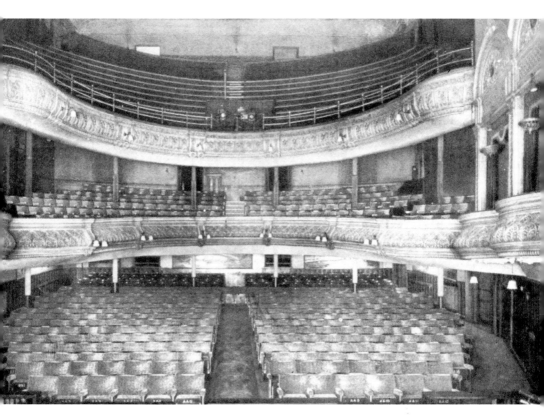

The interior of the Royalty Theatre in 1911. The theatre on City Road was built by Bleakley builders from Birkenhead in 1882. It was a large theatre with two ornate curving balconies supported on six columns. Oil paintings by T.R. Clarkson adorned its walls. It could seat an audience of 2,000. However, it had alterations in 1958 which changed the balconies and interior to allow for a greater variety of entertainment. Many famous artists performed at the theatre including Marie Lloyd, Sir Harry Lauder, Henry Irvine, the Beatles, Frankie Vaughan and Ken Dodd. The theatre closed in 1966, having provided entertainment in Chester for eighty-four years.

Opposite top: The Chester Telegraph Boys are shown in a group photograph before going on an outing in summer 1916. These telegram delivery boys were aged between 10 and 18 and were employed by the Post Office. They wore distinctive uniforms and used bicycles to get around as quickly as possible to deliver telegrams. During the First World War they had a difficult job as they were usually the bearers of the bad news that a soldier was missing in action or had been killed on active service. For such young men this must have been very stressful as they were dealing daily with family tragedy in their own communities.

Bottom: Victory in Europe Day on 8 May 1945 formally marked the end of the Second World War and Hitler's defeat. There was much rejoicing throughout the land. This photograph shows a happy group of men outside the Plumbers Arms at No.21 Newgate Street in Chester on VE Day. They are ready to start the celebrations, which were thoroughly deserved.

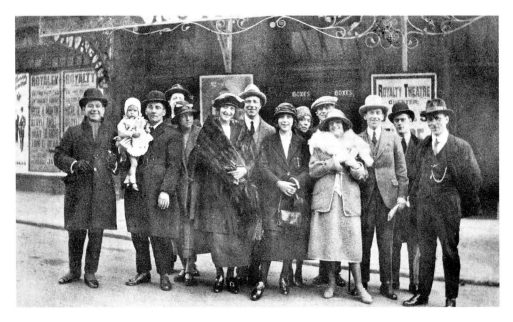

A happy gathering of performers and friends outside the Royalty Theatre in City Road, c.1920. At the centre of the group are Beryl and May, who danced as the 'Two Violets'.

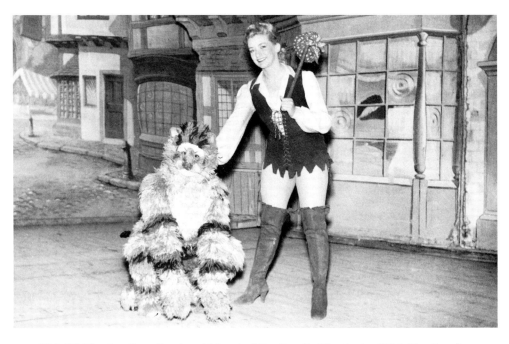

Dick Whittington (June Ross) and his cat at the Royalty Theatre in 1957. The Royalty pantomimes were always enjoyable and much admired by Cestrians and visitors to Chester alike. They would usually have a full house during the entire production. (Photograph by W.J. George of Guilden Sutton, Chester

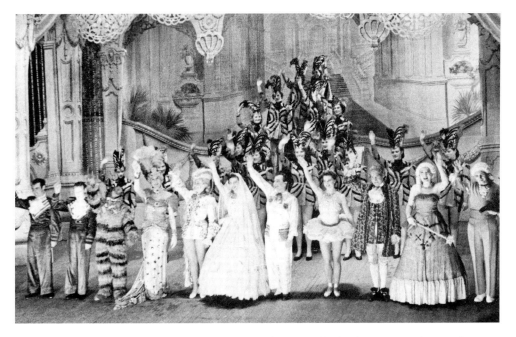

The cast of Dick Whittington wavie to the audience at the final curtain at the Royalty Theatre in 1957. (Photograph by W.J. George of Guilden Sutton, Chester)

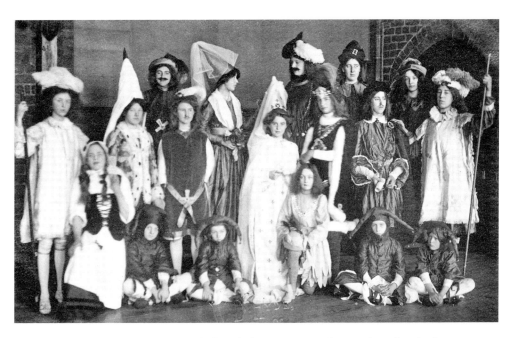

The Queen's School performed the Shakespeare comedy *Love's Labour's Lost* on 3 December 1908. This was a major production for the school and the full cast are shown in this photograph taken by W.D. Hyde of 30 Duke Street, Chester.

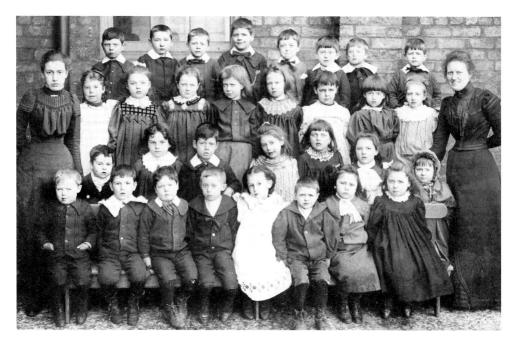

Pupils from St Thomas of Canterbury School in Walpole Street photographed with their teachers, c.1895. They are all smartly dressed for this special occasion. Most of the boys are wearing high-buttoned jackets and stiff white collars. The girls are in their best dresses and both teachers are dressed in black blouses and long skirts.

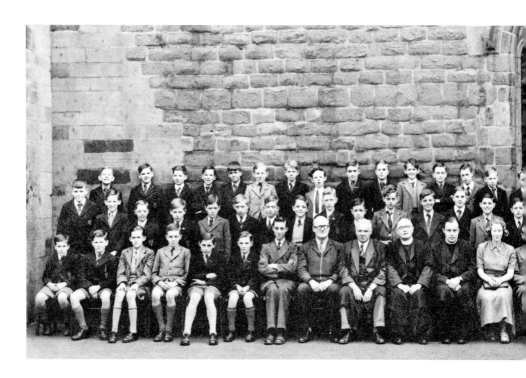

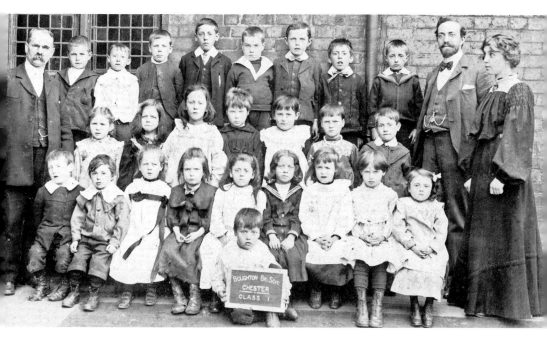

Class 1 at Boughton School, Chester, *c.*1895. Most children are wearing their best clothes and some of the girls have pinafores over their dresses. The class teacher, dressed in a black skirt and blouse, stands on the right and it is likely that the man with the bowtie next to her is the headmaster.

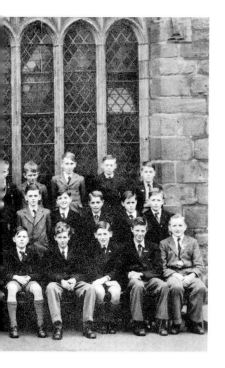

The staff and pupils from the Chester Cathedral School, summer term 1948. This school had been set up in a house in Abbey Square in 1850 for the choristers of the cathedral as it was felt they should have their education together as a group. They had previously attended the King's School, which was on the site of the Bishop's Palace in Werburgh Street (see page 41). In 1920, the Cathedral School moved into rooms above St Anselm's Chapel. Classes were small and the school day was programmed to fit in with the cathedral services. The choir school closed in 1975. Now the cathedral choristers come from all schools in the Chester area.

A charming photograph of a brother and sister in their school uniform taken by Silvester Parry in his studios at Godstall Lane, St Werburgh's Street, *c.*1900. The boy, who attends the King's School, is pictured with his mortar board and the girl, who attends the Queen's School, is holding her beret.

11

SPORT AND LEISURE

The city walls and Nuns Road, c.1905. The Roodee and racetrack are shown on the left. The road on the right was built in 1901 on land which belonged to St Mary's Nunnery until the Dissolution in 1537. The White Friars (Carmelites), the Black Friars (Dominicans) and the Brown Friars (Franciscans) also had land on this side of the city until the time of Henry VIII. Streets in Chester today recall these religious orders; however, the named streets do not correspond to the original positions of their houses.

JIMMY WALSH, (CHESTER)

LIGHTWEIGHT CHAMPION OF GREAT BRITAIN.

Under direction : DOM & TONY VAIRO, 5, Breck Road, Liverpool.
Phone : NORTH 1133.

Southern Area and Foreign Representative : JOHN S. SHARPE,
3, Edward Street, London, E.I. Phone: EAST 6233.

Jimmy Walsh was born at Chester in October 1913. He showed an early talent for boxing and became an outstanding fighter under the management of Tony Vairo. During his career (from 1931 to 1940), he won seventy-one fights (including seventeen knock-outs) and lost twenty. He became the Lightweight Boxing Champion of Great Britain at Liverpool Stadium on 24 April 1936 when he beat Jack Kid Berg, stopping him in the ninth round. He held the title for two years with many successful fights but finally lost his crown when he was beaten on points over 15 rounds by Dave Crowley at Anfield Football Ground on 23 June 1938. The Second World War interrupted his fighting career and he did not have an opportunity to regain his title. He died on 13 September 1964 at the early age of 51.

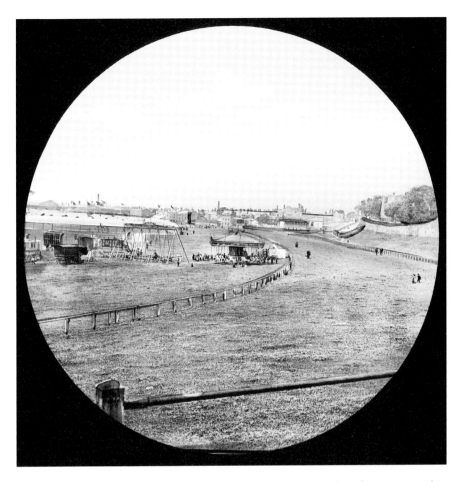

A photograph from a lantern slide showing the fairground with swings and a merry-go-round on the Roodee, *c*.1900. At that time the fairground was within the racetrack, but later the fair was held on the Little Roodee. The showman, Pat Collins, was born at Boughton on 12 May 1859 and attended St Werburgh's School. He became the leading showman of his generation. He brought his funfair to Chester every May during the Races. He also owned a chain of cinemas which included the Majestic in Brook Street. He settled in Walsall but never forgot Chester. He supported Chester Royal Infirmary and also donated a beautiful carved marble pulpit to St Werburgh's Church in 1894. Among his many accomplishments, he was Liberal MP for Walsall from 1922 to 1924. It is believed that he was offered a knighthood by Neville Chamberlain, which he declined, saying that he wished to remain 'plain Pat Collins'. He died on 9 December 1943, aged 84.

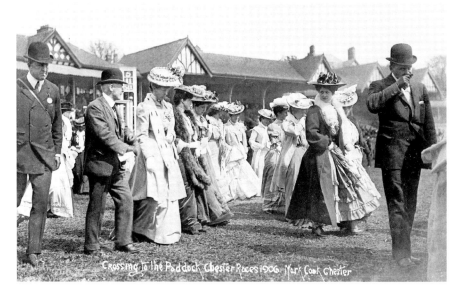

Crossing to the Paddock Chester Races 1906. Mark Cook Chester

In 1539 the Roodee was first used as a racecourse by Henry Gee, the Mayor of Chester, making it the oldest racecourse in England. The Chester Race Company was formed in 1893 when charges were first made for admission to the races. In this photograph, taken by Mark Cook, the gentlemen accompanied by their ladies are shown crossing to the paddock to watch the horses in the parade ring at Chester Races in 1906. The parade ring was then in the centre of the course in front of the County Stand.

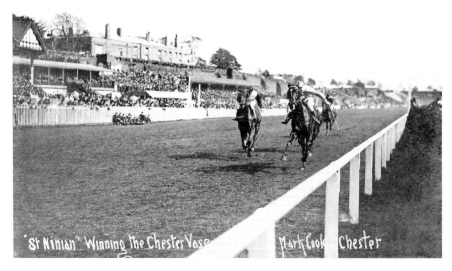

'St Ninian' Winning the Chester Vase. Mark Cook Chester

St Ninian winning the Chester Vase in a close finish in 1909. The races attracted many visitors to Chester and crowds here line the city walls and pack the stand and terraces. The compact Chester course has difficult bends for the horses, but the great advantage for spectators is that they can enjoy views of the whole course from the walls and grandstands.

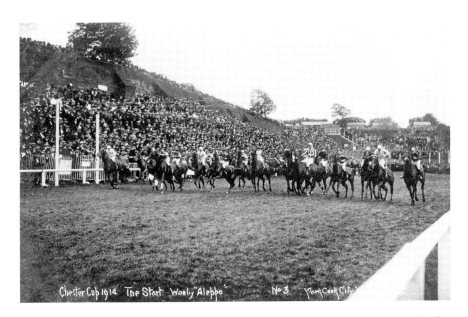

The photograph by Mark Cook shows huge crowds watching the horses lined up for the start of the Chester Cup in 1914. The race was won by Mr Fairie's Aleppo, ridden by Charlie Foy. The Chester Cup (originally called the Tradesmen's Cup) was first contested in 1824.

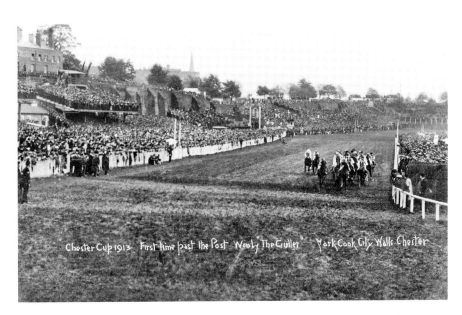

Another photograph taken by Mark Cook showing the first past the post in the Chester Cup in 1913. There was another circuit of the track to complete. The race was won by 'The Guller'. The writer of the postcard says, 'This gives a good idea of the Races on Cup Day – but sad to relate the family wealth was not on the winner!'

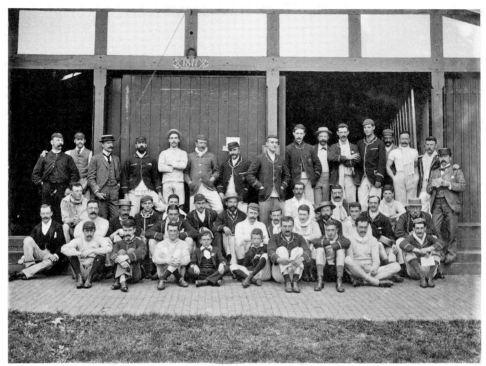

Royal Chester Rowing Club.
1893.

Above: The Royal Chester Rowing Club was founded in 1838 and given royal patronage in 1840, making it one of the oldest rowing clubs in the UK. In 1856 the club became the first amateur eight ever to represent the North of England at Henley. In their boat *Eugenie* they won both the Ladies' Plate and the Grand. The club continued to do well in competitions. This photograph shows members of the Royal Chester Rowing Club outside their club house by the River Dee in 1893. The club house was built in 1877 and the date can be seen engraved in the woodwork over the boat bay doors.

Opposite top: There has been rowing on the River Dee for over 1,000 years. The Chester Regatta had its first competitive race in 1733, making it the oldest rowing regatta of its type in the world. It became a popular event and large crowds would gather on the banks of the river to cheer on the competing boats. This postcard, dated 24 July 1907, shows the Royal Chester Rowing Club Senior Quad on the left winning the race for the City of Chester Challenge Cup. The writer of the card says, 'It is the first time the club had won this big race for ten years'.

Bottom: Crowds line the riverbank outside the marquees at Chester Regatta in this postcard dated 24 July 1907. It is a busy social scene with many people arriving by rowing boat before the competitive races start on the river. The postcard was published by Will R. Rose of Cathedral Buildings, Chester.

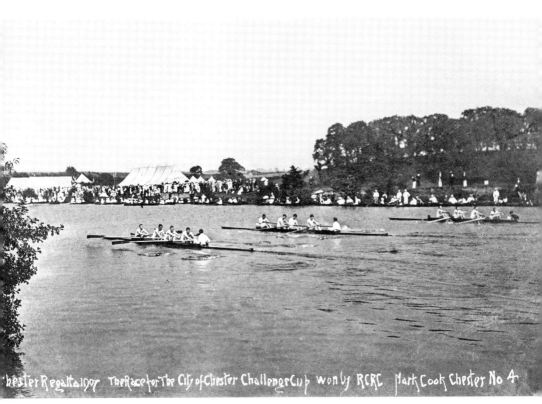

hester Regatta 1907 The Race for The City of Chester Challenge Cup won by RCRC Mark Cook Chester No 4

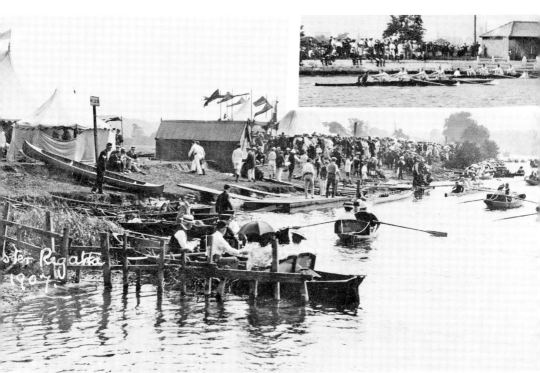

ster Regatta 1907

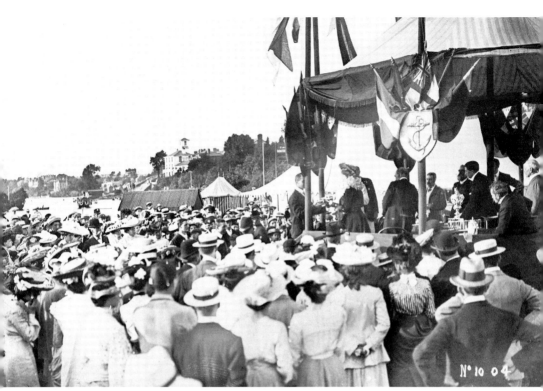

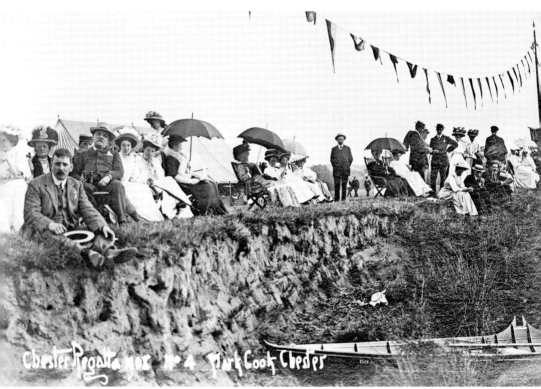

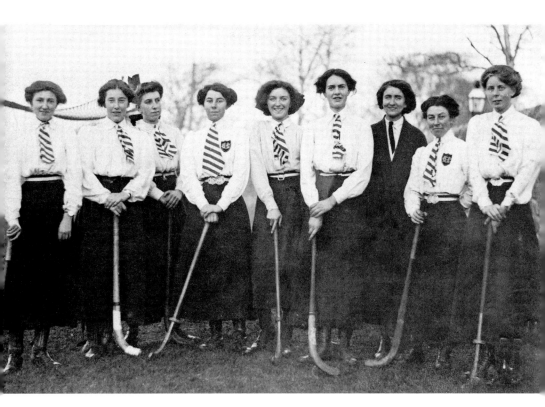

Above: The Chester Ladies Hockey team pictured on a postcard dated 15 December 1911. The writer of the card to her friend in Kensington says that 'this is only a part of the 1st XI team'. The team kit with the long skirts is very different from today. At that time, hockey was mainly played by women who had learned the game at public school or university. This would change after the First World War and Chester Ladies Hockey Club was revived with new colours in 1926.

Opposite top: Crowds surround the platform to cheer the winners at the presentation of the prizes at Chester Regatta in 1904. The writer of the postcard – sent to his girlfriend in Blackpool – says he is just making his way to the platform with his crew to receive the Cup after winning his race at the Chester Regatta.

Bottom: A photograph of the crowds on the riverbank at the Chester Regatta in 1908, taken by Mark Cook. The regatta was a popular annual event and a great social occasion for the spectators. To get a good view of the races they would line the Long Reach on the river between Earl's Eye and Heron Bridge. Many would bring picnics and there were also refreshment tents. The umbrellas were used not just in the event of rain but also to give protection from the sun!

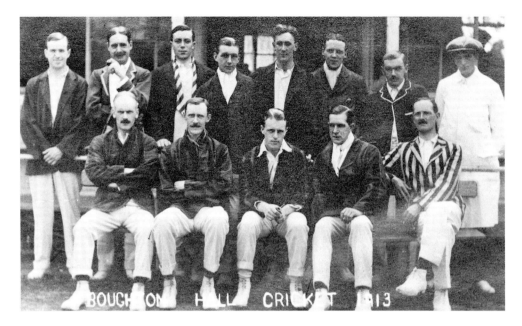

Above: Boughton Hall Cricket Club dates back to 1873. The benefactor at that time was John Thompson, who owned Boughton Hall and wanted to start a Chester City cricket club. They played their first match in May 1873 against Arnold House School (see page 6). Over the years the club has prospered and it is now the premier cricket club in Chester. The photograph, taken by Chidley, shows the Boughton Hall First XI cricket team in 1913. The club captain from 1913 to 1930 was R. Frost.

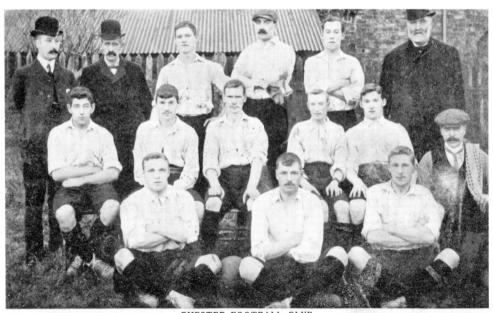

CHESTER FOOTBALL CLUB.

W. Fletcher *(Sec.)* E. T. Hollmark. T. Delany. W. Coventry. W. Barker. W. Coventry *(Treas.)*
W. Matthews. E. O'Neil. T. Case. R. White. J. Lipsham. B. Eardley *(Trainer)*.
PHOTO BY R. SCOTT & CO., MANC. J. L. Hughes. J. W. Jones. J. W. Dawson.

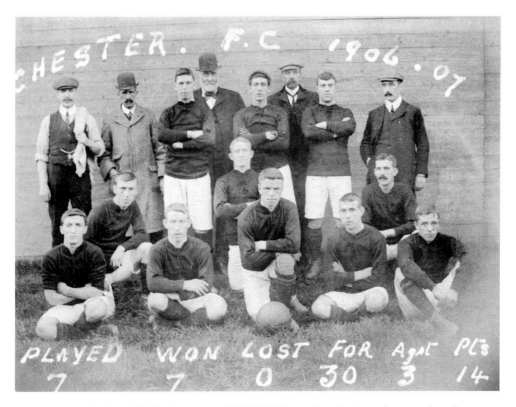

Chester City Football Club team in 1906/07. When this photograph was taken they were unbeaten, having played and won seven games with an impressive goal tally. On 15 December 1906 Chester played their first game at the Sealand Road ground against Bangor, which they won 4-0. However, the early form was not maintained throughout the season and Chester once more finished the season as runners-up, on this occasion to Whitchurch in the Combination League.

Left: Chester City Football Club team in 1904/5. From left to right, back row: W. Fletcher (Secretary), E.T. Hallmark (Chairman), T. Delany (Captain), W. Coventry, W. Barker, W. Coventry (Treasurer). Middle row: W. Matthews, E. O'Neil, T. Case, R. White, J. Lipsham, B. Eardley (Trainer). Front row: J.L. Hughes, J.W. Jones, J.W. Dawson. The team played in the Combination League and their ground was at Whipcord Lane on a field owned by Lord Crewe. They finished the season as runners-up to Wrexham in the Combination League.

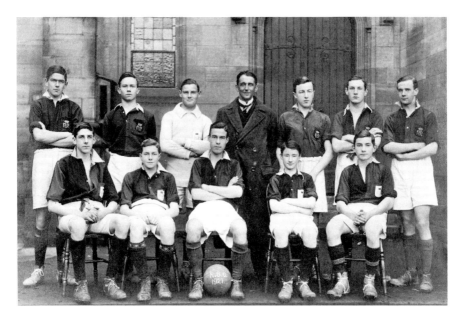

King's School First XI football team, 1920/21. From left to right, back row: E.W. Taylor, R. Bussen, ? Thomas, Mr Fletcher, A.K. Miln, G.B. Lee, R.W. Dunn. Front row: W.P. Hale, J.B. Kendrun, D. Parry, ? Roberts, ? Payne.

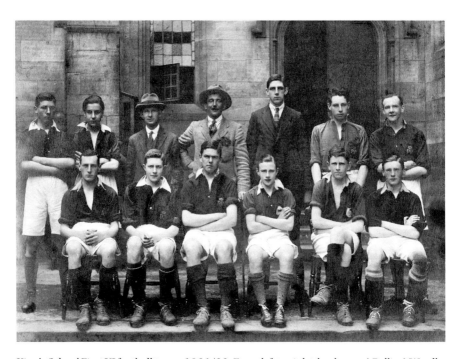

King's School First XI football team, 1921/22. From left to right, back row: ? Bellis, ? Wardle, Mr Willis, Mr Elishchet, W.P. Hale, R.W. Dermody, K.W. Dunn. Front row: G.B. Lee, J.B. Kendrun, E.W. Taylor, ? Jones, ? Taylor, W. Sproson.

12

EARLY DAYS OF
CHESTER COLLEGE
(NOW THE UNIVERSITY OF CHESTER)

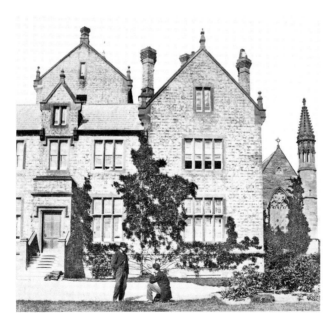

Chester College principal's house taken from a stereoview, *c*.1890. The chapel is on the right. The college was founded in 1839, making it one of the oldest colleges in England: only four were founded before Chester – they were Oxford, Cambridge, Durham and London.

Chester College First XI football team, 1892/93. The photograph is taken outside the principal's house, and John Dugdale Best is shown standing behind the team at the top of the steps on the left.

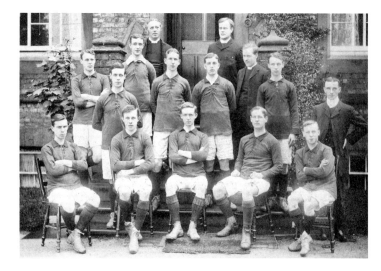

Chester College First XV rugby team, 1892/93. The college began playing rugby in 1889.

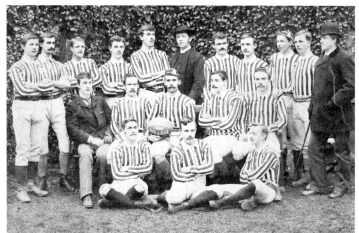

Chester College First XV rugby team, 1907/08. From left to right, back row: ? Womessley, ? Perkins, ? Adams, ? Gelling, ? Hayes, ? Panter, ? Stockley, ? Lagshaw, ? Taylor, ? Ranicar (Trainer). Middle row: ? Elm, ? Fisher, ? Irlam (Captain), ? Davies, ? Harding. Front row: ? Hopwood, ? Northmore.

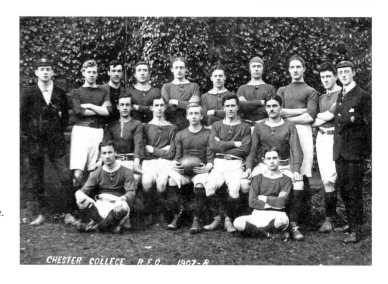

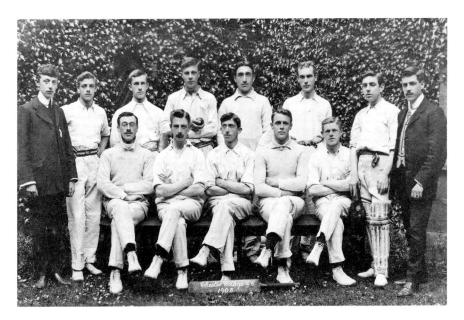

Chester College First XI cricket team, 1908. From left to right, back row: ? Woodbine, ? Roberts, ? Humphreys, ? Daniel, ? Buckley, ? Hardman, ? Cooper, ? Copley. Front row: ? Bebington, ? Milner, ? Whitehead, ? Williams, ? Huyton.

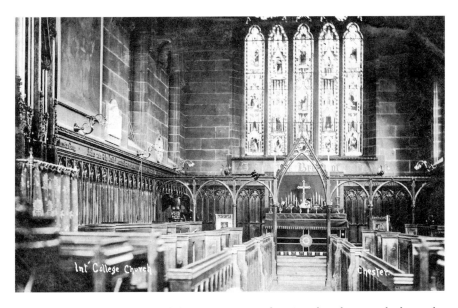

Chester College Chapel was built between 1844 and 1847. This photograph shows the interior of the chapel from the west gallery. At that time students at the college mastered many trades. It is remarkable that much of the chapel stonework, the whole of the interior carved woodwork, seating, panelling, the front for the organ case and some of the stained glass were all the work of the college students. Their workmanship is much admired and the chapel continues to serve the university today.

Chester College Wireless Society started in June 1922 and wireless messages were being sent and regularly received by March 1923. This postcard, from 1923, shows the wireless at Chester College, which had five valves. The students helped to build the wireless. It was not portable but it was an example of the most modern radio equipment for that time. The poster on the wall lists the Wireless Transmitting Stations and their call signs.

The teaching staff at Chester College, c.1910. The college principal, John Dugdale Best, who held the position from 1890 to 1910, is seated in the centre of the group.

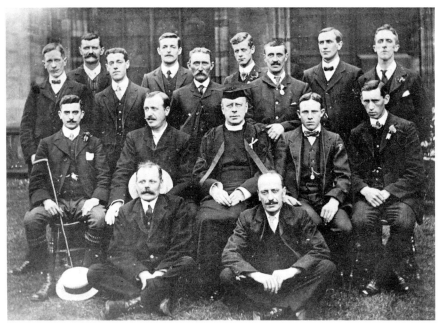

A photograph showing the daughter of Principal John Dugdale Best, taken in the summer of 1908.

The Proclamation for the battle between the Muffs and the Duffs, which was drawn on parchment by N.H. Ridley in 1908. It reads: 'According to ye custom sides of ye Muffes will engage in mortal combat with ye Duffes. Ye great battle will take place on ye 27th Day of October.' This annual college battle was a football match – but not as we know it!

The Guard at the annual Muffs versus Duffs battle, which took place on 27 October 1908. They have smart uniforms and their task was to keep order on the day, which was not always easy as the rules of engagement were open to interpretation! From left to right, back row: ? Sheward, ? Caton, ? Billington. Middle row: ? Adams, ? Dawber, ? Thomason, ? Rowson. Front row: ? Brooks, ? Owen, ? Robinson (Captain), ? Mee, ? Binns.

The procession on the terrace at Chester College on the occasion of the annual battle between the Muffs and the Duffs on 24 October 1907. The two men leading the procession are Mr Panter and Mr Williams. After this the order of procession was predetermined and included the Rasperian Band, the Chaplain and Presenter, the Duff captain, the Speech Bearer, the Duff team, the Scorer, the Water Carrier, the Ball Scrubber, the Ball Chasers, the Corner Flags, the Muff captain and the Muff team

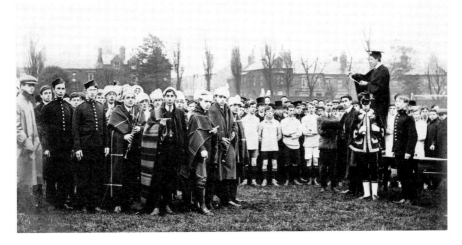

The Address in the College Park to the teams and their supporters before the game. There was much pomp and ceremony and all were exhorted to give no quarter and play the game. The young men wrapped in tartan blankets with musical instruments formed the Rasperian Band, who would play throughout the afternoon. The photo was taken by W.A. Lamb, who had his studio in Victoria Road.

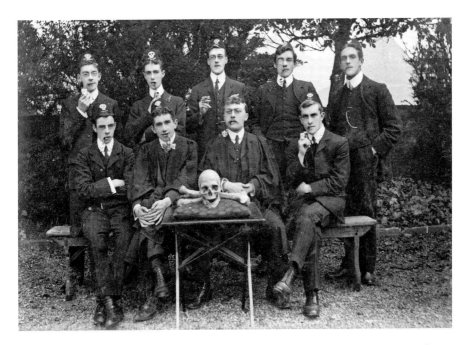

The 'Dramatic' Group of Chester College, c.1908. This serious-looking bunch are taking part in the Muffs v. Duffs game and are all wearing cap badges with a skull and crossbones motif. They look suitably fearsome seated behind a table with a real skull and crossbones while smoking their clay pipes. They are ready to guard the Duffs. From left to right, back row: ? Rostron, ? Langshaw, ? Robinson, ? Bell, ? Kilcross. Front row: ? Hardman, ? Nicholls (Chairman), ? Ridley, ? Ross.

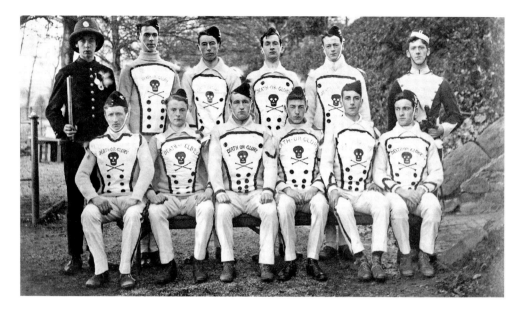

Another smartly dressed Duff's Guard looking ready for action. The writer of the postcard in December 1910 to his father in County Durham says they were 'appointed to take ye men off the field'. They are wearing tops with a skull and crossbones motif and the motto 'Death or Glory'. It sounds seriously competitive but the day was a chance for students to let their hair down and the tomfoolery was always enjoyed by everybody taking part.

The Mock Trial at Chester College in December 1910. The suffragettes were represented by R. Waites, U. Sutcliffe and A. Ireland. This card was posted from the College by Oswald White to his sister in Warrington on 31 January 1911. At that time the Women's Suffrage Movement was fighting for equality for women and the right to vote. This did not happen until well after the end of the First World War. Following the Equal Franchise Act of 1928, women over the age of 21 received the vote on the same terms as men. However, it was 1962 before women were admitted to Chester College.

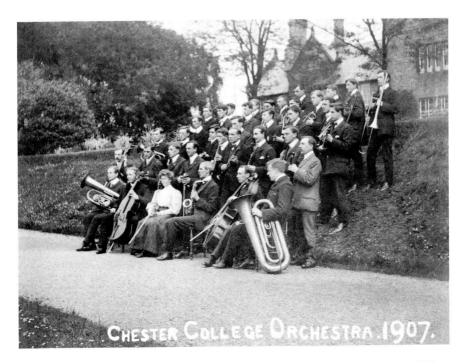

The Chester College Orchestra in 1907. The Principal's daughter (see page 137) is seated on the front row. The music tutor and director of the newly formed orchestra was Theodore Ardern, said to have been an inspirational leader.

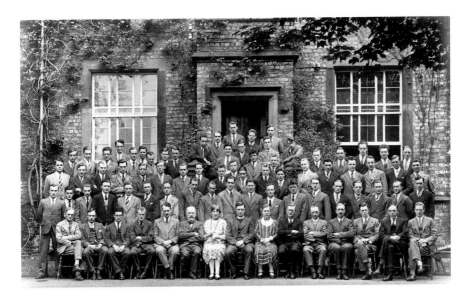

The Principal, Revd Canon Richard Thomas, is seated at the centre of the front row photographed with the senior year students and the tutors at Chester College in 1930. The Revd Thomas was an old boy of the King's School. He was on the college staff from 1896 to 1905 and served as principal from 1910 to 1935. The photograph was taken by Chidley.

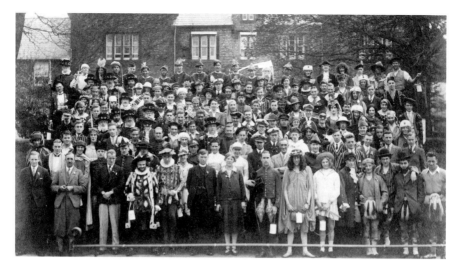

The first Chester College Rag was held on 18 March 1922 and raised £100 for good causes. After this success the Rag became an annual event which replaced the battle between the Muffs and the Duffs as a vehicle for the students to relax and fool around. However, it was all for a good cause and was enthusiastically supported by the students. This photograph shows the College Rag in 1929. Principal Thomas is standing near the centre of the front row surrounded by a large number of students and staff dressed in various familiar and exotic costumes. There are quite a few 'Yeomen of the Guard'. They are ready to set out in procession to the city to request and cajole donations for charity from the citizens of Chester.

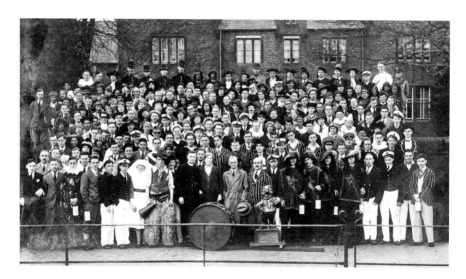

Virtually all the staff and students are photographed here before the Chester College Rag in 1930. Principal Thomas stands to the left of the big drum. The Rag was a good-natured affair which involved a lot of preparation. However, there was great support from the whole college and staff and students were all involved in designing costumes. Their efforts were much appreciated by the Chester residents and visitors who enjoyed the spectacle and gave generously to help those most in need.

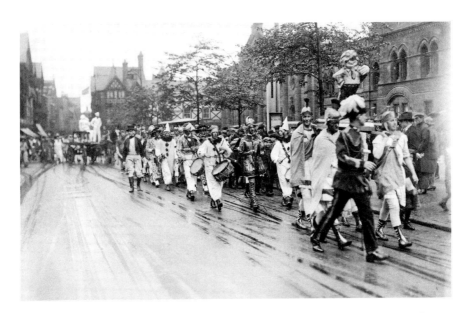

Chester College Rag Day in the early 1950s. The students in fancy-dress march into town in procession with their collecting tins at the ready. It was a fine display with the drummers leading the way. There were many decorated floats with various displays which were supported by local businesses. The parade always attracted many spectators who lined the pavements. It was not every day that they could see drummers, clowns, Roman soldiers, sailors, nurses, singers, mummies and other exotically dressed performers walking the streets of Chester! Here the students are seen passing the Town Hall carrying the mascot which was seen in the front row of the previous photograph for the 1930 Rag.

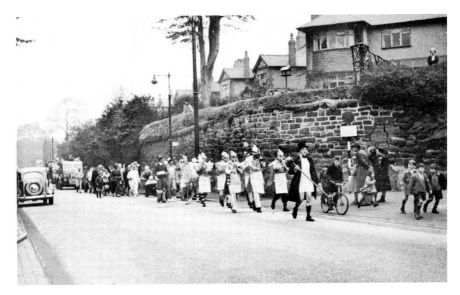

Chester College Rag Day in the 1950s. Great efforts were made by all the students to maximize their collection for charity. Here the procession of students and decorated floats from the college led by the band are pictured heading up Parkgate Road towards town.

Chester College Rag Day, 18 October 1958. A brave student dressed for the office with his bowler hat and briefcase is pictured walking with determination up Parkgate Road. The writer of the postcard says, 'This is Geoff and his barrel'. Who could refuse him a donation?